此展獻給所有在烏克蘭為了自由而奮鬥的人民

This exhibition is dedicated to all the people in Ukraine who are defending their freedom

目次 Contents

序
Forewords

p. 6 — 李永得 / 中華民國文化部 部長
Lee Yung-Te / Minister of the Ministry of Culture, Republic of China (Taiwan)

p. 8 — 梁永斐 / 國立臺灣美術館館長
Liang Yung-Fei / Director of the National Taiwan Museum of Fine Arts

p. 10 — 阿魯納斯・格盧納斯 / 立陶宛國家美術館館長
Arūnas Gelūnas / Director of the Lithuanian National Museum of Art

p. 14 — **策展專文**
Curatorial Essay

烏格涅・瑪麗亞・馬考史凱德 / 策展人
Ugnė Marija Makauskaitė / Curator

尤斯蒂娜・奧古斯地德 / 協同策展人
Justina Augustytė / Co-curator

作品圖版
Plates

p. 22 — 認同即現實
Identity as Reality

p. 82 — 認同即物件
Identity as an Object

p. 112 — 認同即概念
Identity as a Concept

p. 146 — **藝術家簡介與圖說**
Artists' Introductions and Captions

中華民國文化部 部長序文

首次來臺展出的「揭幕：尋探立陶宛攝影中的認同」以立陶宛國家美術館的收藏為主，結合部分藝術家與私人收藏，展出自 1950 年代以來，立陶宛攝影發展中各階段的重要作品。展覽依循著攝影藝術在立陶宛發展的時序分為三個單元：「認同即現實」、「認同即物件」和「認同即概念」，反映出這些照片在拍攝、創作當下的社會氛圍。位在波羅的海東岸的立陶宛是個富有生命力的國家。走過前蘇聯的占領、極權政府的統治與全面打壓，這個距離臺灣八千多公里遠的國家，在歷史上和我們有著諸多相似之處與困境。透過借鏡立陶宛攝影藝術，臺灣觀眾甚或能更有共感地回頭認識臺灣攝影藝術史，質疑多被視為理所當然的認同與其歷史形塑。

本展覽由國立臺灣美術館與國家攝影文化中心合作辦理，四月在國立臺灣美術館展出，隨後於九月移展至國家攝影文化中心臺北館。「揭幕：尋探立陶宛攝影中的認同」以立陶宛國家攝影藝術為範疇，以「認同」作為策展軸線，除了向臺灣觀眾介紹立陶宛攝影史歷程外，也讓我們重新理解認同與其混雜多元的樣貌。

文化部極為珍惜此次與立陶宛國家美術館所建立的國際情誼，國美館與攝影文化中心也因應立陶宛攝影展而推出同樣以「認同」中心議題的當代攝影藝術展，開啟兩國在藝術與文化上的首次對話，希望臺灣的民眾能藉此對立陶宛攝影史與臺灣當代攝影藝術境況有更多認識與情感共鳴，更期盼這次的展覽能為日後更深更廣的文化交流揭開序幕。

中華民國文化部 部長

Minister's Foreword |

Uncoverings: The Search for Identity in Lithuanian Photography, the exhibition coming to Taiwan for its first time, is mainly composed of works from the collection of the Lithuanian National Museum of Art (LNDM) and combined with some works from artists and private collections. The exhibition presents important works from each stage of the development of Lithuanian photography. Following the chronology of the progress of Lithuanian photography, the exhibition is divided into three sections: "Identity as Reality," "Identity as an Object," and "Identity as a Concept," reflecting the social atmospheres when these photos were taken. Lithuania is a lively nation on the eastern shore of the Baltic Sea. Having experienced the occupation of the Soviet Union as well as rules and total repressions by authoritarian governments, Lithuania, a country over 8000 kilometers away from Taiwan, shared with us many similar aspects and faced similar predicaments throughout history. Through Lithuanian photographic art, the audience in Taiwan would probably look back and understand the history of photography in Taiwan with more resonance, questioning identities and historical formations that have usually been left unquestioned.

This exhibition is co-organized by the National Taiwan Museum of Fine Arts (NTMoFA) and the National Center of Photography and Images (NCPI). It will first open at the NTMoFA in April and later tour to the NCPI Taipei in September. *Uncoverings: The Search for Identity in Lithuanian Photography* sets itself within the scope of the photographic history of a single nation and is curated along the axis of "identity". It not only introduces the historical process of Lithuanian photography but allows us to reach for a renewed understanding of identity, and its hybrid and diverse appearances.

The Ministry of Culture has a great pleasure to cherish the international friendship with LNDM established this time. The NTMoFA and the NCPI, in response to this exhibition of Lithuanian photography, also presents a contemporary photography exhibition centering on the issue of "identity" and opens up for the first time a conversation on art and culture between the two countries. Through these exhibitions, we hope that people in Taiwan can have more understanding as well as emotional reverberation towards the history of Lithuanian photography and the contemporary photographic art in Taiwan, and we wish this exhibition can inaugurate deeper and broader cultural exchanges in the future.

Lee Yung-Te
Minister of the Ministry of Culture, Republic of China (Taiwan)

國立臺灣美術館 館長序文

來自波羅的海的立陶宛，對許多人而言或許相對陌生，但深入了解後，眾人將折服於其豐厚之人文與藝術的歷史面貌。因近期 COVID-19 的流行，立陶宛向臺灣致送口罩與疫苗，始為國人所認識，也因此搭起了國際友誼的橋樑。由立陶宛國家美術館所策畫的「揭幕：尋探立陶宛攝影中的認同」，展出自 1950 年代以來，立陶宛攝影發展中各階段的精彩作品，其中多數是其重要的館藏。為了回應立陶宛方的心意，本館也以「認同」作為對話的主軸，向遠方的觀眾，呈現臺灣精彩的當代攝影發展切片。

認同是極為複雜的議題，多元、變異與流動乃其不可忽略的特質，因此，誠如策展人所言，「揭幕：尋探立陶宛攝影中的認同」雖依循攝影藝術在立陶宛的發展時序作規劃，但其更重要的目的是藉由不同世代藝術家，因為相異的時代背景與創作意識而呈現之生命力的舞動，持續地以創作的力量「撼動」固著且僵化的世界觀與身分認同。這些展出的攝影作品，向國人演示了想像力的無限可能；未來在鏡頭之外，未來也超越國與國之間的歷史與文化藩籬。立陶宛在歷史上和我們有著諸多相似之處與困境，但更重要的是，我們都相信藝術所傳達、溝通的人文主義思想與價值信念。參照立陶宛的歷史進程，臺灣觀眾或許能從不同視角，深入認識自身的文化，進而質疑各種既定的意識形態。

相當榮幸地，本館有機會接下此一文化交流里程碑的重責大任，持續且積極地辦理對外文化溝通的工作，也將抱持審慎態度向國人展現深具文化力與藝術力的展演成果。與立陶宛的交流展，在結束國美館的首站之後，皆將於九月移展至國家攝影文化中心臺北館，介紹給臺北的觀眾。立陶宛國家美術館決定將此展致獻給正飽受戰火摧殘的烏克蘭，國美館也與立陶宛站在一起，深信藝術是跨越國界的共通性語言，也是全人類共享且應追尋的精神信念，得以戰勝各種困境。讓我們期待後續更多且深遠的兩國交流。

國立臺灣美術館 館長

Director's Foreword

Lithuania, situated by the Baltic Sea, may be relatively unfamiliar to many of us. However, as we probe deeper, we would be impressed by the rich historical faces of its humanities and arts. During the recent widespread of COVID-19, Lithuania donated facemasks and vaccines to Taiwan. This allowed us to know about the country and also to put up a bridge of international friendship. Organized by the Lithuanian National Museum of Art (LNDM), the exhibition *Uncoverings: The Search for Identity in Lithuanian Photography*, presents wonderful works from various stages of the development of Lithuanian photography since the 1950s, and most of the exhibits belong to the collection of the LNDM. In response to the kindness of the LNDM, the National Taiwan Museum of Fine Arts (NTMoFA) also takes on "identity" as a topic of dialogue, presenting fascinating facets of contemporary photography in Taiwan to the audience afar.

Identity is an extremely complex issue, while diversity, mutability, and fluidity are its unneglectable characteristics. As the curator states, even though *Uncoverings: The Search for Identity in Lithuanian Photography* is organized by chronological order of the development of photography in Lithuania, a more important goal of the exhibition is to "shake" the fixed and rigid worldviews as well as identities through the power of artistic creation via the dance of vitality presented by artists of different generations working under dissimilar historical contexts and artistic consciousness. These exhibited photographic works show the infinite possibilities of imagination, which in the future may go beyond the lens and cross the historical and cultural boundaries between countries. As Lithuania and Taiwan shared many similarities and predicaments throughout history, it is more important that we all believe in the humanistic thoughts, values, and beliefs that art expresses and communicates. Taking the historical process of Lithuania as a reference, the audience in Taiwan may be able to better understand our own culture from different perspectives, and further question all kinds of presupposed ideologies.

The NTMoFA is very honored to have the opportunity to be responsible for this cultural exchange milestone, continuously and actively working on cultural communication overseas, and carefully presenting to our people exhibitions as well as performances of abundant cultural and artistic value. After first being held at the NTMoFA, this exhibition will tour to the National Center of Photography and Images, Taipei, and open to the local audience. As the LNDM has decided to dedicate this exhibition to war-torn Ukraine, the NTMoFA stands together with the LNDM, believing that art is a border-crossing common language and a spiritual belief, which all human beings share and should pursue so as to overcome all kinds of difficulties. Let us look forward to further deepening exchanges between the two countries in the future.

Liang Yung-Fei
Director of the National Taiwan Museum of Fine Arts

立陶宛國家美術館 館長序文

致具同理心的臺灣藝術愛好者

對於策展團隊、參展攝影藝術家以及眾多博物館從業人員而言，新展覽面世的時刻總是令人激動又充滿挑戰。展覽的受眾是國際大眾時，更是令人激動，但也多了一分不確定性：展覽的預期受眾是否能以對自己和策展方都有助益的方式，理解展覽所呈現的訊息？如果展出的藝術品之創作脈絡幾乎不為預期受眾所知，那麼觀者理解的又是什麼？又，另一項因素使得本次策展任務變得更加複雜——數十億張攝影圖像充斥眼前，對我們來說，實體和虛擬環境往往會模糊化美學與日常的界線、教育觀眾與娛樂觀眾之間的界線，以及追求真理和「沉迷於美學式的消費主義」（引用蘇珊·桑塔格的名言）之間的界線。

在這種情況下，每位策展人都希望遇到具同理心的藝術愛好者、理想的觀展者，也就是準備好參與詮釋進程並探究未知事物的人。諷刺的是，這兩年來新冠肺炎大流行，這個你我休戚與共的空前局面，竟然能促成而非阻撓這場獨特藝術品的展出，這是因為人們受夠透過 Zoom 和 Teams 等線上會議軟體溝通，都渴望與真實的人事物進行實體互動。

我們生活在訊息快速流通的時代，資訊以前所未有的速度穿越國界快速傳播，人們對轉譯和詮釋有持續不斷（甚至是每天）的需求，而集結在一起。「揭幕：尋探立陶宛攝影中的認同」這項全景式展覽，橫跨了 60 年、囊括 21 位攝影師的藝術作品，呈現了一項艱鉅的詮釋任務。這 60 年中有 33 年，立陶宛這片土地被一支外國軍隊佔領；因此立陶宛人常說，二戰正式結束的時間點，是在 1993 年 8 月 31 日最後一名俄羅斯士兵永遠離開立陶宛的時候。過去 60 年所凝練的，絕不是個不斷進步或持續發展的故事，而是個由沉悶和多彩、悲慘和歡樂的經驗片段所拼湊而成、明暗交織的故事。此外，世代鴻溝是立陶宛攝影史的一大特徵。為此，策展人烏格涅·瑪麗亞·馬考史凱德（Ugnė Marija Makauskaitė）和協同策展人尤斯蒂娜·奧古斯地德（Justina Augustytė）規劃出展覽的三重結構——認同即現實、物件、概念。他們必須與至少三世代的攝影師交涉合作，從 1950 年代後期所謂的「赫魯雪夫解凍」到近期發起攝影實驗的年輕立陶宛攝影師——皆為立陶宛獨立後藝術機構的畢業生。為了處理大量社會、政治和文化事件以及風格迥異的攝影師，三重結構是一個便捷的工具，但僅代表諸多可能詮釋中的一種。

或許有人認為，既然攝影被認為是最「客觀」和「中立」的圖像創作方法之一，展現在他們眼前的，即是 1960 或 1980 年代蘇聯時期立陶宛的「現實」或「真相」。然而在這裡必須提醒的是，打從攝影學科開始興起時，創作「搬演式攝影」就是攝影實踐的一部份，而且，蘇聯領導人希望攝影師所展示的「現實」與攝影師自己願意投射凝視的「現實」有很大的差異。著名的衝突矛盾例如：當今國際知名的攝影界明星安塔納斯‧蘇庫斯（Antanas Sutkus）將其作品〈盲眼的小紅軍〉刊登於一份蘇聯日報後，幾乎被禁止從事攝影工作，該照片所展示的蘇聯青年形象，與共產主義理想相距甚遠。這批選集的照片背後有許多類似的故事。

礙於「前言」的體裁，我無法進一步分析藝術品或為觀者提供觀展建議。我由衷感謝許多人和機構，沒有他們的參與，這個激勵人心的交流計畫就不可能實現。首先感謝立陶宛文化部駐外文化參事托瑪斯‧伊萬納斯卡斯先生（Tomas Ivanauskas）發起了與國立臺灣美術館（NTMoFA）的合作計畫，沒有邁出這一步，這項交流計畫便無法誕生。由衷感謝國立臺灣美術館館長梁永斐先生對來自立陶宛陌生夥伴的信任，使這次交流成為可能。我亦誠摯感謝策展人烏格涅‧馬考史凱德女士和協同策展人尤斯蒂娜‧奧古斯地德女士在創建這項策展計畫和構思佈展策略時的努力和創造性洞見。

我希望，對於所有思想開放和具同理心的臺灣藝術愛好者來說，與立陶宛攝影的相遇，將是一次正向、富教育意義和愉快的經驗，也希望這次的展覽進一步推動我們未來幾十年的合作。

阿魯納斯‧格盧納斯
立陶宛國家美術館 館長

Director's Foreword |

To the empathetic Taiwanese art-lover,

The presentation of a new exhibition is always an exciting and challenging moment for the curatorial team, for the photographers involved and for the vast number of museum professionals directly related to it. The presentation of a new exhibition to the International public probably doubles this excitement and adds to it an element of risk: will the message of the exhibition be understood by the intended public in a way that is more or less rewarding for both sides – the organizers and the visitors? What will be comprehended if the context of the creation of the artworks presented is almost entirely unknown to the public in question? An additional factor makes the task of successfully presenting a photography exhibition even more complicated - saturated with billions of photographic images, our physical and virtual surroundings tend to melt the borderline between the aesthetical and the everyday, the desire to educate and the desire to entertain, the quest for the truth and the "addiction to aesthetic consumerism", to quote the famous dictum by Susan Sontag.

In such a situation, every curator dreams about the empathetic art-lover, the ideal visitor to the exhibition. One who is ready to engage in an effort of interpretation and to uncover the unknown. Ironically, the unprecedented situation we have all been facing for the last two years because of the COVID-19 pandemic works for rather than against the experience of the unique artwork as we all crave real encounters with real people and objects, having had enough of Zoom and Teams communication.

Since we live today in an era of global communication in which information traverses state borders with unprecedented speed, so we are united by a constant – indeed everyday – need for translation and interpretation. The panoramic project of *Uncoverings: the Search for Identity in Lithuanian Photography* presents quite a formidable task of interpretation as it encompasses the art of 21 photographers and covers a 60-year period. 33 of those 60 years were spent with a foreign army on Lithuanian soil; Lithuanians are therefore fond of saying that World War II only ended for them on the 31st of August, 1993 when the last Russian soldier left Lithuania for good. Thus, for Lithuania these past 60 years have by no means been a story of constant progress or uninterrupted development but rather a mosaic of the bright and the dark of dull and colourful, tragic and joyful experiential fragments. Moreover, it is marked by the generational divide that has inevitably resulted in the tripartite structure of the exhibition (Identity as: Reality/Object/Concept) offered by its curator Ugnė Marija Makauskaitė and co-curator Justina Augustytė. They have had to deal with at least three different generations of photographers stretching from the so-called "Khrushchev Thaw" in the late 1950s up to the most recent experiments by young Lithuanian photographers – graduates of the art institutions of an independent Lithuania. This structure is a convenient tool for approaching this vast collection of social, political and cultural events and the great variety of photographers, but represents only one of many possible interpretations.

Observers might be tempted to think that, since photography is regarded as one of the most "objective" and "neutral" methods of image-creation, what reveals itself in front of their eyes is "the reality" or "the truth" of, let us say, the Soviet Lithuania of the 1960s or 1980s. However, we need to remember here that the creation of "staged photographs" has been a part of photographic practice from the very beginnings of the discipline and that there was a great difference between the "reality" that Soviet leaders wanted photographers to show and the "reality" that the photographers themselves were willing to turn their gaze on. Famous conflicts arose: for example, Antanas Sutkus, today one of the internationally acclaimed stars of the photographic world, was nearly forbidden from practicing photography following the publication of his picture *The Blind Pioneer*, which showed an image of Soviet youth that was as distant as it was possible to be from the communist ideal, in one of the Soviet dailies. There are many similar stories behind the photos in this collection.

The genre of the "foreword" prevents me from engaging more deeply in the analysis of the artworks or recommendations for the spectators. I would rather like to sincerely thank a number of people and institutions without whose engagement this exciting exchange project would not have been possible. I would first like to thank the cultural attaché of the Republic of Lithuania to China and South Korea Mr. Tomas Ivanauskas for initiating the cooperative project between the National Taiwan Museum of Fine Arts (NTMoFA) – a first move without which this exchange project would not have been possible. My heartfelt thanks go to the director of the National Taiwan Museum of Fine Arts, Mr. Yung Fei Liang, for trusting the as yet unknown partner from Lithuania, and making this exchange possible. I am sincerely thankful to the curator Ms. Ugnė Makauskaitė and co-curator Ms. Justina Augustytė for their hard work and creative insight while creating this project, and conceptualizing the presentation strategies.

I hope that the encounter with Lithuanian photography will be a rewarding, educational, and pleasant experience for all open-minded and empathetic Taiwanese art-lovers, and one that will fuel our cooperation for decades to come.

Arūnas Gelūnas
Director of the Lithuanian National Museum of Art

CURATORIAL ESSAY 策展專文

揭幕
尋探立陶宛攝影中的認同

烏格涅・瑪麗亞・馬考史凱德
尤斯蒂娜・奧古斯地德

「揭幕：尋探立陶宛攝影中的認同」耙梳時光洗練下，立陶宛攝影中身分認同的發展與探尋。歷史脈絡在此極為重要——重大歷史事件和國家政治不僅影響藝術創作及傳播，亦影響個人間的互動。策展人所彙編的敘事難免主觀，在此僅提供觀者眾多認識立陶宛攝影的其中一種角度。這樣的編排方式並未試圖規避論述角度上的矛盾，而是旨在擴大作品之間的多方對話，使意想不到，卻有說服力的聯想得以浮現。本展覽由三個部分組成，依時序及主題排列為：「認同即現實」、「認同即物件」和「認同即概念」。

展覽的第一單元——「認同即現實」，呈現了立陶宛攝影自 1950 年代起逐漸成形的開端。針對蘇聯佔領的這一時期，眾人擁有不同的詮釋。1944 年，立陶宛的國力因第二次世界大戰、希特勒的德軍占領及種族屠殺而被削弱，遂被蘇聯侵占。對應立陶宛人民的反抗，蘇聯進行了大規模的驅逐和其他形式的鎮壓。佔領政權積極推行蘇維埃化的政策、經濟和國內改革（國營化、集體農業），並限制傳統、信仰及創作自由。這段極其艱困的佔領時期持續到 1990 年，同時也是立陶宛攝影逐漸發展成形的時期。1950 至 1960 年代，也就是所謂的「解凍」時期，在赫魯雪夫（Nikita Khrushchev）的統治之下，政府對藝術創作的意識形態限制逐漸放鬆，攝影開始被視為一項獨立的藝術創作領域。脫離蘇聯時代陰鬱、貧困的日常，這時期的攝影家以隱喻來創作，傳達人文主義精神；而只有最勇敢的攝影家才膽敢捕捉赤裸裸的社會現實。因此，攝影既是支持意識形態的工具，亦是對抗意識形態的手段。藝術家不斷地在審查制度的限制和自我表達的需求之間遊走。

UNCOVERINGS
The Search for Identity in Lithuanian Photography

Ugnė Marija Makauskaitė

Justina Augustytė

This exhibition follows the story of the development and exploration of identity in Lithuanian photography through time. Historical context, the major historical events and politics of the state that affected not only artistic creation and its dissemination, but also the dynamic world of individuals, is extremely important here. The story created by the curators is subjective and offers only one of the many ways to get acquainted with Lithuanian photography. It does not avoid contradictions and inconsistencies, but aims only to widen the polylogue between the works and allow unexpected but eloquent connections to arise. The exhibition consists of three parts that follow both chronological and thematic guidelines: "Identity as Reality", "Identity as an Object" and "Identity as a Concept".

The works in the first part – "Identity as Reality" – present the beginning of the formation of Lithuanian photography from the 1950s onwards. This period, the years of the Soviet occupation, is open to many interpretations. In 1944, Lithuania, weakened by World War II and Hitler's German occupation and genocide, was occupied by the Soviet Union. Resistance in the population was suppressed by mass deportations and other forms of repression. The occupying power actively pursued sovietisation policies, economic and domestic reforms (nationalisation, collectivisation), and the restriction of traditions, faith, and creative freedom. This was an extremely difficult period of occupation that lasted until 1990 and during which Lithuanian photography developed. It started to be seen as a separate field of artistic creation in the 1950s and 1960s, during the so-called period of the "thaw", when the ideological regulations imposed on art were relaxed during the rule of Nikita Khrushchev. Turning away from the gloomy, impoverished everyday life of

展覽的第二部分——「認同即物件」，探討立陶宛歷史與文化的轉變。此單元的展品創作於布里茲涅夫（Leonid Brezhnev）領導之下的蘇聯時期（1964-1982），也是所謂的「停滯」時期，反映了大多民眾對蘇維埃政權的適應與轉變——即便大多數人並非蘇聯的狂熱信徒。1972年，19歲的羅馬斯・卡蘭塔（Romas Kalanta）為抗議蘇聯的佔領而自焚，成了這種絕望的悲慘象徵。戈巴契夫（Mikhail Gorbachev）於1985年上台，他的「改革重建」政策也為立陶宛解放的初步跡象開闢了道路。在大規模抗議和政治改革運動此起彼落之下，自蘇聯佔領以來，「立陶宛做為一個獨立國家」的概念首度被公開地表述。而這樣的概念與訴求在1990年3月11日成為現實；立陶宛共和國最高議會簽署了《立陶宛獨立法案》，標誌著立陶宛迎向自由的開始。1980年代初期在立陶宛藝術領域嶄露頭角的一代攝影家見證了這樣的政治轉變。他們在作品中突顯了蘇聯時期的疲憊及徒勞，巧妙地藉由日常物件探討這些主題。同時，與上述相異、更大膽的創作理念開始滲透到攝影之中，透過對新興主題的探索和創新之攝影語彙萌芽發展。

第三部分——「認同即概念」展出21世紀的攝影作品。截然不同的政治環境以及出國旅遊、受教育的機會持續增加，使得創作的自由和多元性得以破繭而出。此時期嶄露頭角的藝術家作品幾乎無法一言以蔽之——當代立陶宛攝影面向多元且層次繁複。藝術家從不同角度研究社會，以強調身分認同充滿疑問的本質，並從基礎「撼動」世界觀，鼓勵觀者思考不尋常、甚至尷尬的議題，質疑既定的態度，並找到作品所探討問題的多重答案。他們的攝影作品揭示了個人與群體、隱私與公開、過去與現在、外在與內在世界之間的連結和衝突。這些面向透過對自身在世界中持續探索的渴望和重新想像，而結合在一起。

the Soviet era, photographers created visual metaphors expressing humanistic ideas, and only the bravest dared to capture the unadorned social reality. Photography was therefore both a tool to support ideology and a means of combating it, and artists were constantly maneuvering between the restrictions of censorship and the need for self-expression.

The second part of the exhibition – "Identity as an Object" – explores the transformation of Lithuanian history and culture. It followed on from the era of Leonid Brezhnev's leadership of the Soviet Union (1964–1982), also known as the "stagnation" period, which marked the adaptation of a large part of the population to the Soviet regime, although most people were not fervent believers in the USSR. The self-immolation of the nineteen-year-old Romas Kalanta in protest of the USSR's occupation in 1972 became a painful symbol of this despair. Mikhail Gorbachev came to power in 1985 and his policy of "perestroika" opened the way for the first signs of liberation in Lithuania as well. As rallies, mass protests and a movement for political transformation took off, the idea of Lithuania as an independent state was publicly expressed for the first time since the beginning of the occupation. This became a reality on 11 March 1990, when the Supreme Council of the Republic of Lithuania signed the *Act on the Re-establishment of the Independent State of Lithuania* thus marking the beginning of a free Lithuania. The generation of photographers who emerged in the field of Lithuanian art at the beginning of the 1980s witnessed this transformation. In their work, they highlighted the fatigue and meaninglessness in the Soviet era, subtly examining these themes through ordinary everyday objects. At the same time different, more boldly creative ideas began to permeate photography, unfolding through the exploration of new themes and innovative photographic language.

本展覽展示了立陶宛國家美術館豐富且不斷增加的館藏，並輔以藝術家出借的私人收藏。為反映立陶宛攝影的發展歷程，本展涵蓋了不同時期藝術家的作品——從幾乎已成典範、被稱為國家「金礦」的經典之作，到年輕世代新興藝術家的攝影作品。立陶宛攝影是個多重聲部的故事，各個時期和潮流的邊界互相重疊，又彼此交織。因此，本次展覽雖然在結構上依循時間順序，但其目的並非要有系統地如實再現該國的攝影歷史，而是為了傳達出藝術家從過去至今使用的媒介和聲音之多元。這些藝術家對於認同（國家、群體、個人層面）的感知形塑有顯著貢獻，並為認同提供了未來的發展路徑。

Works created in the twenty-first century are exhibited in the third part – "Identity as a Concept". Substantially different political circumstances and the growing possibilities for travel and study abroad have unlocked creative freedom and diversity. The works of artists who emerged during this period are almost impossible to summarise – contemporary Lithuanian photography is multidirectional and multifaceted. Artists research society from different angles in order to emphasise the problematic nature of identity and "shake" the foundation of our worldviews, encouraging viewers to think about unusual or even awkward topics, to question established attitudes, and to find answers to the questions explored in their works. Their photographs expose the connections and tensions between the individual and the community, privacy and publicity, past and present, and the external and internal world. These aspects are united by the constant desire to discover and reimagine ourselves in the world.

The exhibition presents works from the rich and continuously growing collection of the Lithuanian National Museum of Art, supplemented by works borrowed from artists. In order to reflect the development of Lithuanian photography, the exhibition includes works by artists from different periods – from the almost canonical, iconic photographs of the so-called national "gold mine" to the works of the young generation of emerging artists. Lithuanian photography is a polyphonic story. The boundaries of its periods and trends overlap and intertwine. Therefore, the exhibition, although based on a chronological structure, aims not so much to systematically and consistently recreate the history of the photography of the country, but to convey the diversity of voices and the medium which was (and still is) used by artists who significantly contributed to the formation of the perception of identity (national, communal, individual), and also offered future trajectories for identity.

羅穆豪達斯・拉考斯卡斯　│　Romualdas Rakauskas

亞歷山德拉斯・馬西豪斯卡斯　│　Aleksandras Macijauskas

亞吉曼塔斯・昆丘斯　│　Algimantas Kunčius

羅穆豪達斯・波澤斯基斯　│　Romualdas Požerskis

維塔斯・呂克斯　│　Vitas Luckus

瑞莫達斯・維克史雷蒂斯　│　Rimaldas Vikšraitis

維吉留斯・尚塔　│　Virgilijus Šonta

安塔納斯・蘇庫斯　│　Antanas Sutkus

瓦克勞瓦斯・史卓卡斯　│　Vaclovas Straukas

IDENTITY
AS
REALITY

認同即現實

現實

欣欣向榮的工業、邁向嶄新生活品質的新興住宅區、鮮花盛開的寬闊街道、蘇聯英雄紀念碑周圍的廣場、在優美的公園裡推著嬰兒車的幸福年輕家庭——在立陶宛的蘇聯佔領時期中，官方批准發布的攝影作品創造了這類蘇維埃統治下的樂觀景象。但現實卻不然，甚至常常荒謬得可笑：官方宣布生產過剩的情況下，各種商品卻持續短缺、貨架空空如也；接受高等教育的年輕人被迫於夏天至農場工作；對西方文化下禁令；甚至連愛情觀都提出政府規範。官方照片與現實間的矛盾不一，是立陶宛攝影在 1960 年代逐漸成形的背景脈絡。立陶宛攝影的正式起點在 1969 年時，立陶宛攝影協會的成立。該協會不僅將攝影視作一項獨立的藝術創作領域，並經營相關教育、創意及傳播活動，更匯聚了活躍的攝影家社群。藝術作品和大眾藝文生活的內容，在蘇俄聯邦社會主義共和國文學與出版事務總局（Glavlit，即 General Directorate for the Protection of State Secrets in the Press，簡稱出版總局）指導下，由官方和藝文組織所組成的縝密網絡所控制。藝術在建立國家形象和意識形態的過程中扮演重要的一角。因此，藝術必須正面描繪國家體制、創造有利於政府當局的公共空間——攝影作品中任何批評的語調是不被樂見的。也因此，要摧毀這個監控體制是不可能的，但藝術家仍然在體制內找尋能使其有效改變的途徑。他們攝影作品中的現實是複雜且多層次的，可視覺化成為邊緣化經驗的痕跡，同時是對當前現實的反映或美學上的表達，彷彿填補了現在以及過去其他可能性之間的裂口。

紀實攝影的傳統和當時的立陶宛攝影有著深切的關係，並決定了其本質。戰後於法國成立的人文攝影學院（以最廣為人知的布列松 Henri Cartier-Bresson 和杜瓦諾 Robert Doisneau 為代表）也對立陶宛的攝影發展影響深遠。人文攝影的準則和社會寫實主義在根本上並不互相抵觸。因此，這個走向汲取了在地特色與各個藝術家根據該地意識形態環境在作品中作的詮釋，進而深耕發展，成為立陶宛攝影的基石。藉由捕捉日常中的片刻，攝影家試圖創造出具有情感吸引力的影像，揭示人類經驗的共同面向並表述了普世價值。而這些作品彷彿脫離了他們所屬的時代，照片中的主角成為符號，生活中面臨的各種情境則成了隱喻。許多此時期的攝影家以拍攝鄉村民眾為主。例如，亞歷山德拉斯·馬西豪斯卡斯

（Aleksandras Macijauskas）拍攝鄉村市集，亞吉曼塔斯・昆丘斯（Algimantas Kunčius）關注地方民眾的週日儀式，而羅穆豪達斯・波澤斯基斯（Romualdas Požerskis）則著重拍攝教區節慶。在觀察和捕捉仍存在於日常生活中的傳統之同時，藝術家試圖抓住逐漸被抹去的民族認同碎片。由於當局要求藝術作品對蘇聯體制下的個人進行正面、積極的描繪，經過修飾、理想化的鄉村照片油然而生。羅穆豪達斯・拉考斯卡斯（Romualdas Rakauskas）透過攝影聯作《盛放》，創造出詩意又生氣勃勃的鄉村生活田園詩來滿足這些期望，這樣的作品幾乎轉化為對良善及柔情的懷舊、甚至成為感傷的寓言。

類似的抒情氛圍在當時攝影圈中盛行。瓦克勞瓦斯・史卓卡斯（Vaclovas Straukas）以《最後的鐘聲》系列記錄了學校的畢業盛宴。他的攝影作品不僅敏銳地傳達了童年到成熟間的轉變，更透過暴露出些許不羈的叛逆和情色，塑造了蘇聯時代青年群像。最令人印象深刻的可能是安塔納斯・蘇庫斯（Antanas Sutkus）的心理肖像創作——在他拍攝孩童、愛侶或任意行人的影像中，強調了存在主義的維度。他作品中所捕捉和敏銳描繪的人物及多元經驗超越了時間限制，轉化成人類身分認同上普遍、象徵性的體現。但遺憾的是，並非所有攝影作品都通過了當時政府的審查。攝影家無聲地掙扎，只能發表自己一部分的創作，而得將其餘作品小心藏起。

即使在眾多限制的條件下，創作從來都不是同質的。有些一開始走人文攝影路線的藝術家後來轉換了方向，捨棄作品中宏偉的主題及隱喻式、振奮人心的處理方式。維塔斯・呂克斯（Vitas Luckus）、維吉留斯・尚塔（Virgilijus Šonta）和瑞莫達斯・維克史雷蒂斯（Rimaldas Vikšraitis）拍攝了蘇聯時代「不存在」的人民，他們的作品強烈又不遮掩、甚至殘酷地傳達了現實。在現實生活中所被壓抑的怒火，在這些描繪社會不公、痛苦和人類對幸福之渴望的照片中展現了出來。觀者很容易對這些作品中的人物產生共鳴——他們不完美，生活未臻理想，且有著獨一無二的個性。這一時期的攝影作品包含了兩種現實：人類作為社會的一員（儘管是被迫的），以及作為一個獨立的個體——由成千上萬個獨特部件所構成的自我。

AS

REALITY

Thriving industry, emerging sleeping districts that promise a new quality of life, wide avenues filled with flowers and squares around monuments to Soviet heroes, young happy families pushing baby strollers in idyllic parks – this kind of optimistic picture of Soviet reality was created in the official, sanctioned photographs from the Lithuanian occupation. But the reality was different and often tragicomic: a constant shortage of various goods and empty store shelves while overproduction was officially declared, young people in higher education forced to work on farms during the summer, the ban on Western culture, and even a government-regulated perception of love. This context of the paradoxical discrepancy between the two realities was where Lithuanian photography was formed in the 1960s. Its official beginning was the foundation of the Lithuanian Photography Society in 1969. The society not only established photography as a separate field of artistic creation and managed its educational, creative and dissemination activities, but also brought together an active community of photographers. The content of artworks and public cultural life were controlled by an extensive network of authorities and creative organisations under the Glavlit (General Directorate for the Protection of State Secrets in the Press). Art was an important part of the process of forming the image and ideology of the state. Therefore, it had to positively depict the state system and create a public space favorable to the regime – critical intonations in photography were not desirable. Therefore, it was not possible to destroy the system, but artists were nevertheless looking for ways to legitimise transformation within it. The reality in their photographs is complex, multi-layered, and visualized as a trace of marginalized experience, and at the same time as a reflection or aesthetic expression of the existing reality, as though filling the gap between what is and what was or could be.

A strong relationship with the tradition of documentary photography determined the nature of photography of that time. The influence of the School of Humanistic Photography, which was formed in France in the post-war years (Henri Cartier-Bresson and Robert Doisneau are its most famous representatives), was also significant. The principles of humanistic photography did not fundamentally contradict the provisions of social realism. Therefore, this direction acquired local peculiarities and interpretations in the work of individual artists based on the influence of the local ideological environment, then entrenched itself and became the foundation of Lithuanian photography. By capturing everyday moments, photographers sought to create emotionally compelling images that revealed common aspects of the human experience and expressed universal values. These photographs seem to break away from their time, their heroes become

symbols, and various situations in their lives become metaphors. Many photographers focused on rural people. Aleksandras Macijauskas concentrated on village markets, Algimantas Kunčius on the Sunday rituals of provincial people, and Romualdas Požerskis on parish festivals. While observing and capturing traditions that were still practiced in everyday life, the artists sought to grasp the fragments of a national identity that was gradually being erased. The requirement to create a bright, positive depiction of a Soviet individual encouraged the emergence of idealised, elevated rural photographs. Romualdas Rakauskas met these expectations by creating the poetic idyll of a flowering village life in his photography cycle *Blooming*, which almost turns into a nostalgic, even sentimental allegory of goodness and tenderness.

A similar lyrical mood prevailed in other photographs of the time. Vaclovas Straukas documented school graduation feasts in his series *The Last Bell*. In his photographs, he not only sensitively conveyed the transformation between childhood and maturity, but also created a general collective portrait of the youth of the Soviet era by exposing hints of rebellion and eroticism unrestrained by uniforms. Perhaps the most memorable psychological portraits were created by Antanas Sutkus, who highlighted the existential dimension in his images of children, couples in love or random, anonymous strangers. The characters and diverse experiences that he captures and sensitively conveys pass beyond time and evolve into universal, symbolic embodiments of human identity. Unfortunately, not all these photographs received the government's approval at the time. Photographers struggled silently to express themselves, and could only publicly show some of their works, hiding others.

Even under conditions of restraint, creative work was never homogeneous. Some artists who had their beginnings in humanistic photography later turned in another direction, abandoning monumental themes and metaphorical, uplifting treatments in their work. Vitas Luckus, Virgilijus Šonta, and Rimaldas Vikšraitis portrayed people who "did not exist" in the Soviet era, and their photographs speak so vividly, openly, even brutally we might say, about reality. The rage suppressed in real life unfolds in photographs filled with social inequality, pain, and a very human desire for happiness. It is easy to identify with the people depicted in these artworks – they are imperfect, living imperfectly, but have unique personalities. The photographs from this period contain both realities: the human being as a member of society, albeit imposed, and the human being as an individual containing hundreds, thousands, millions of unique particles that make up their own personal self.

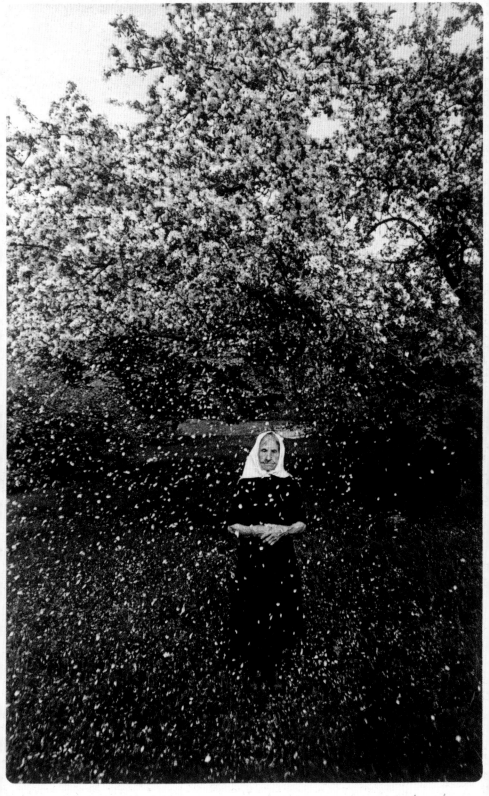

Blossom 12, 1975 R. Rakauskas

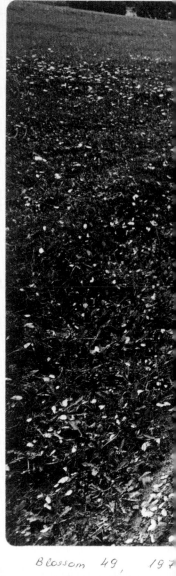

Blossom 49, 197

R. Rakauskas

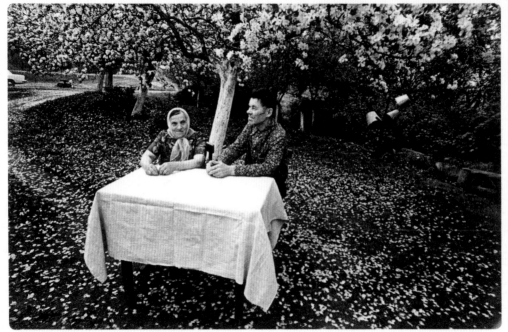

Blossom 4, 1975

R. Rakauskas

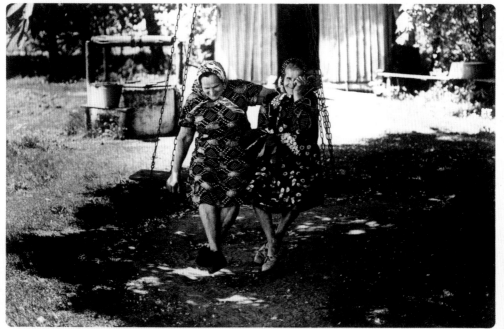

Blossom 72, 1978

R. Rakauskas

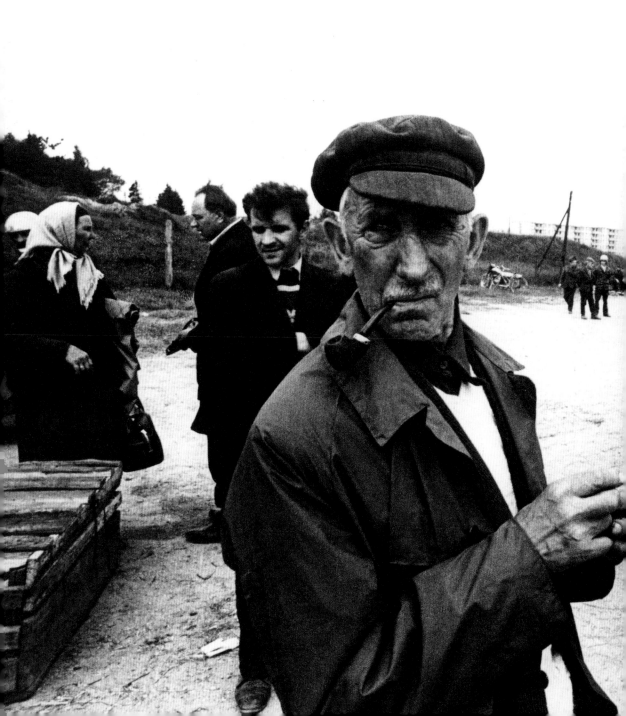

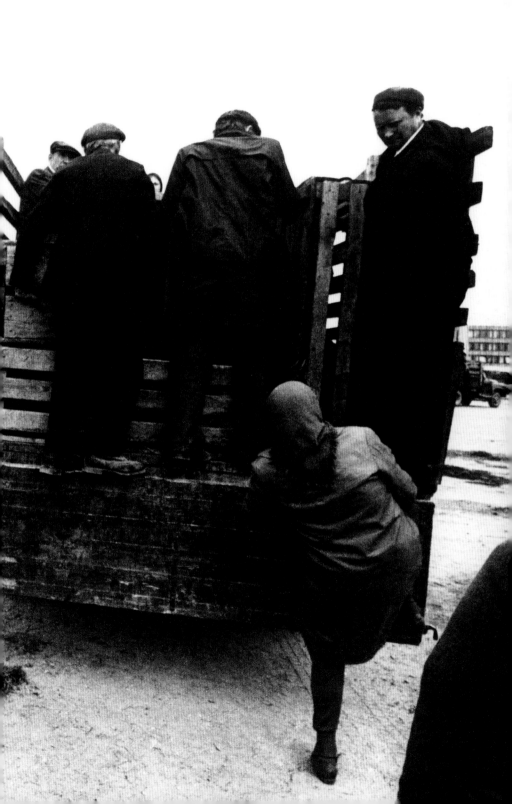

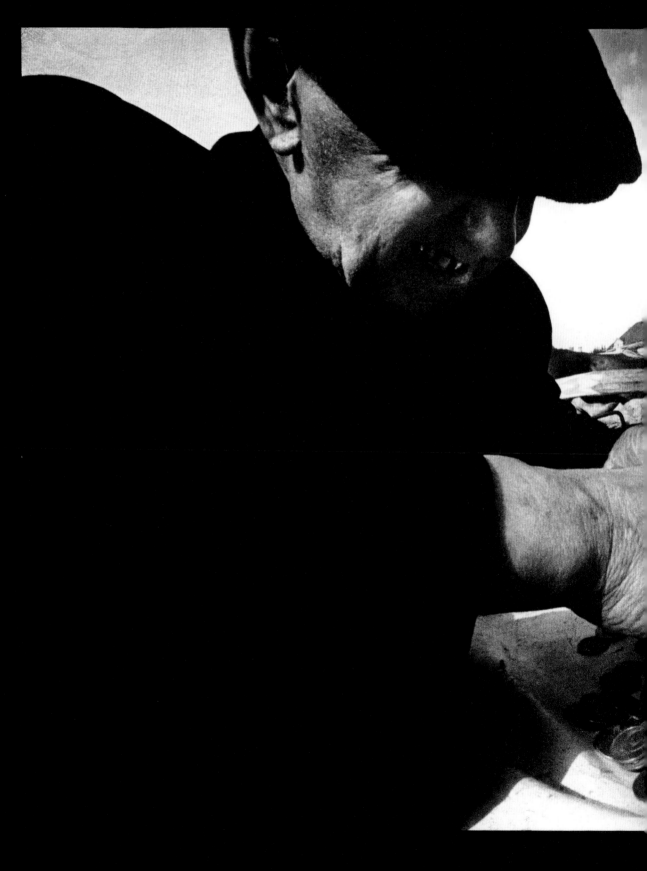

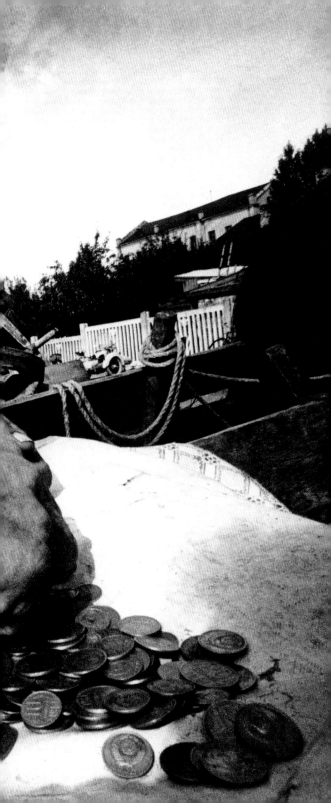

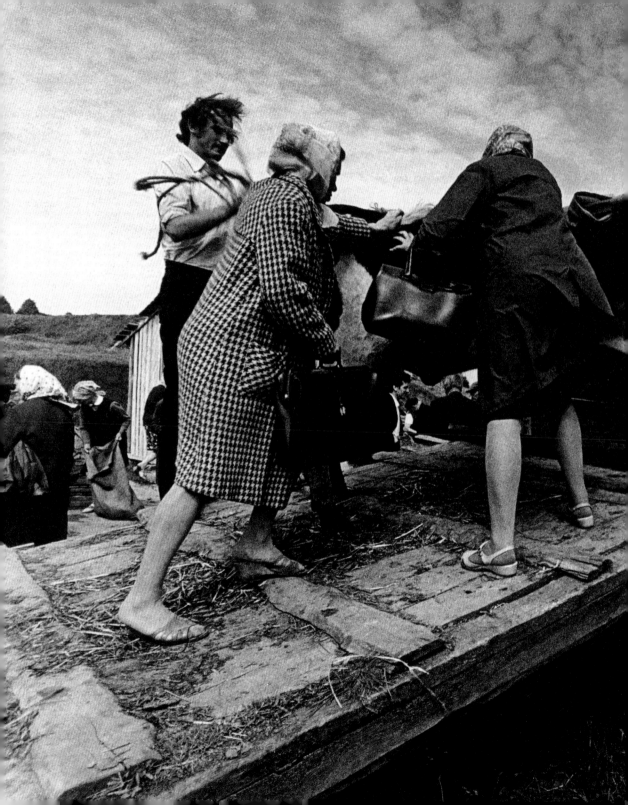

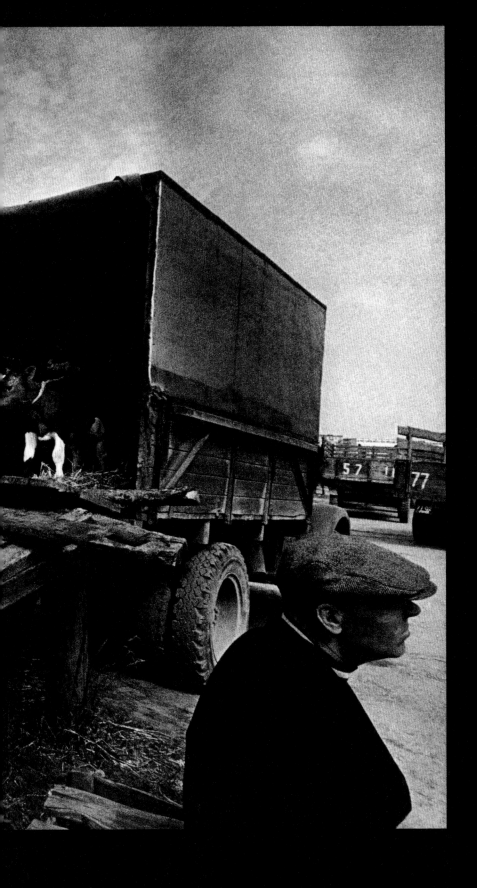

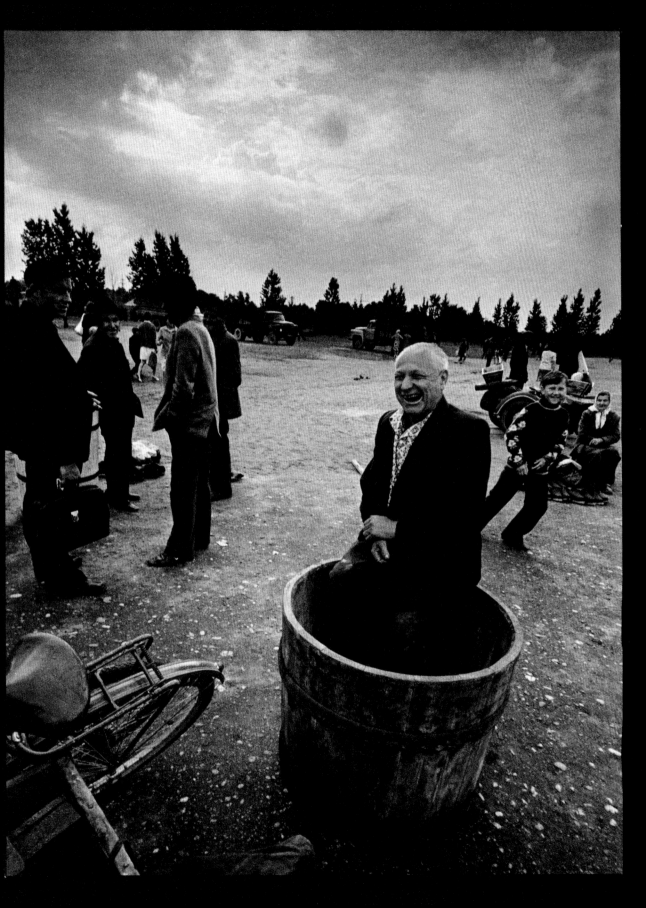

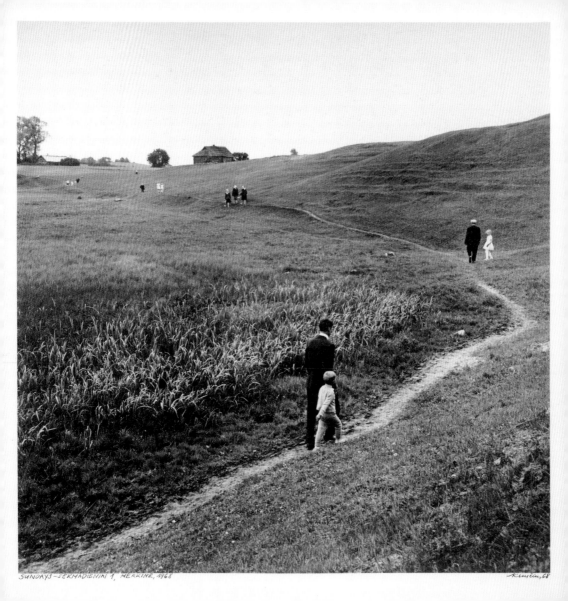

SUNDAYS—SEKMADIENIAI 1, MERKINE, 1968 Kunčius, 68

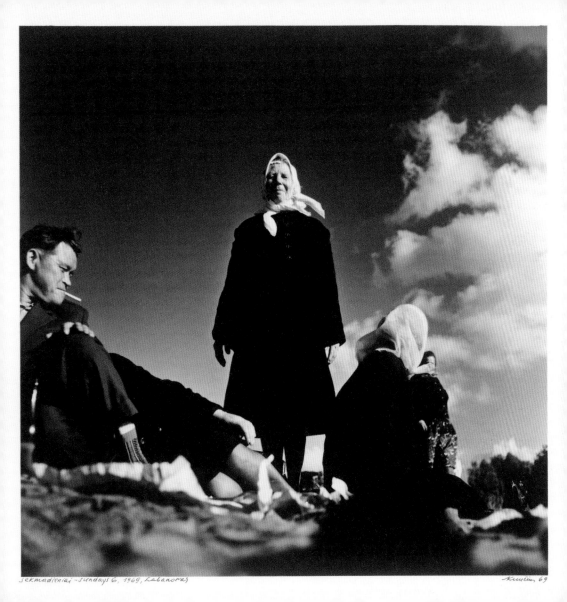

sekmadieniai - Sundays 6, 1969, Labanoras

Kunčius 69

sekmadienis - Sundays 7, 1969 Rokiškio raj, Aleliai Rakauskas, 69

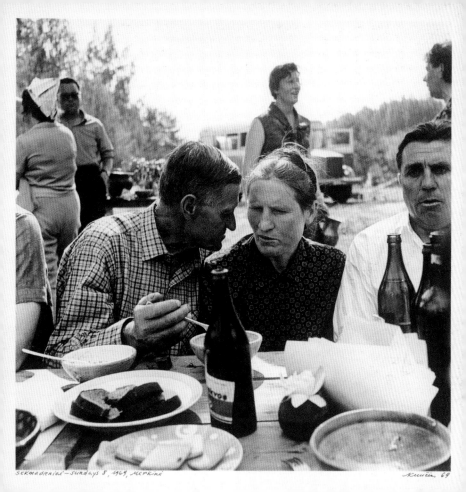

sekmadieniai—sundays 8, 1969, Merkinė Kunčius 69

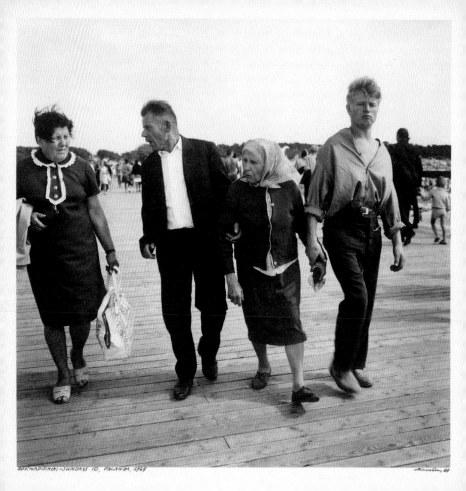

SEKMADIENIS-SUNDAY 10, PALANGA, 1969

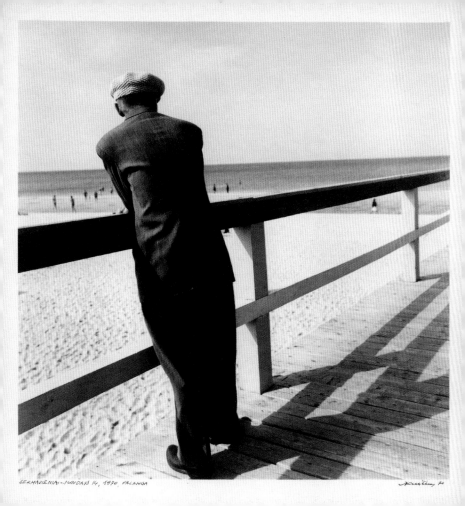

ŠERMADIENIAI·SUNDAYS 4, 1970, PALANGA

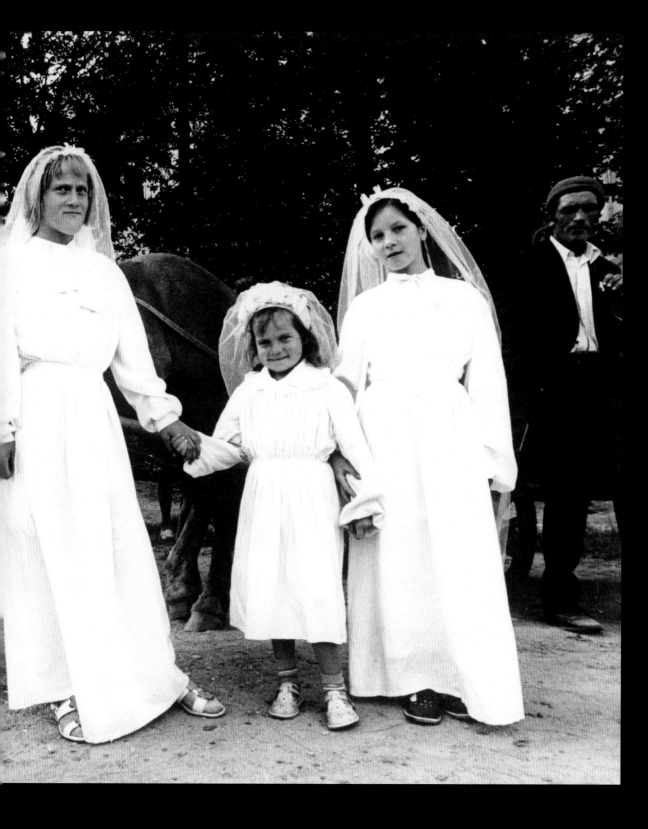

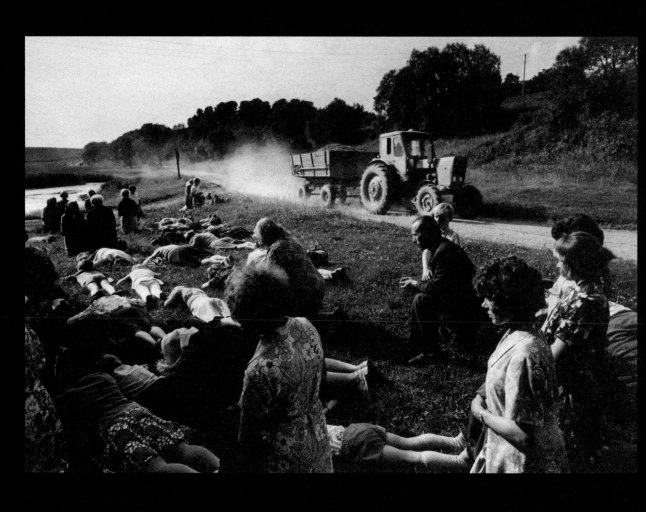

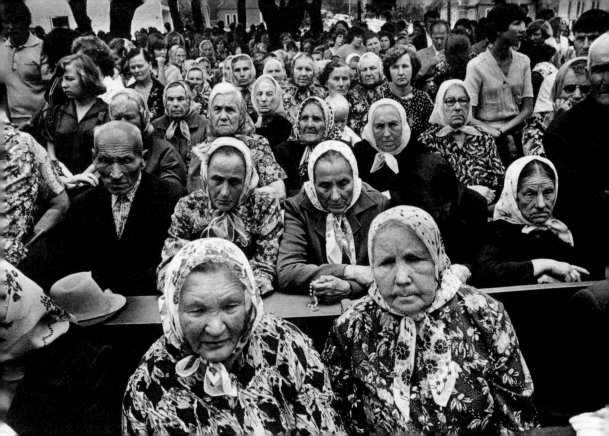

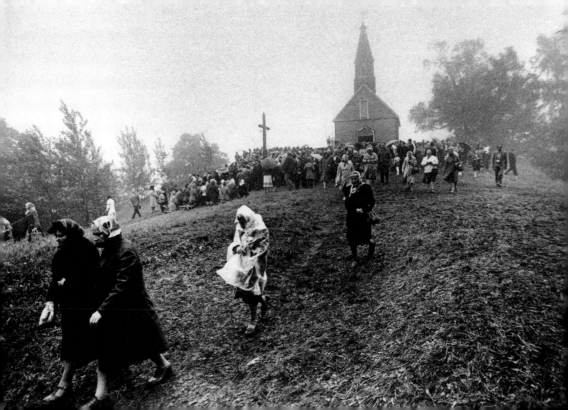

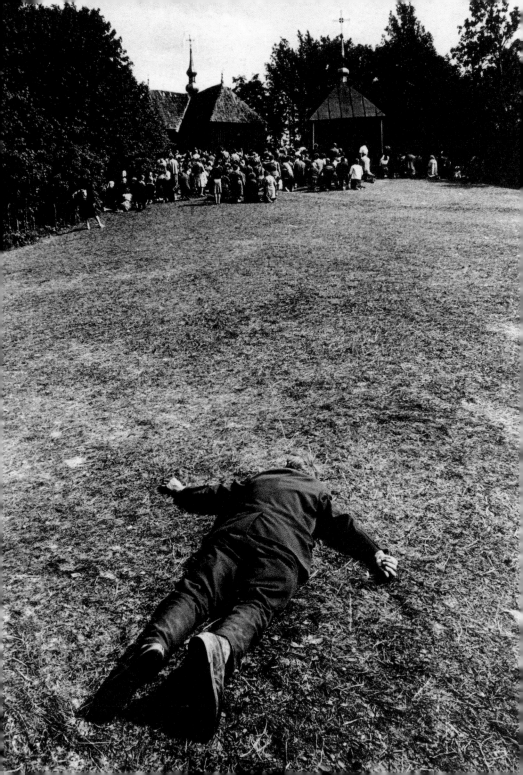

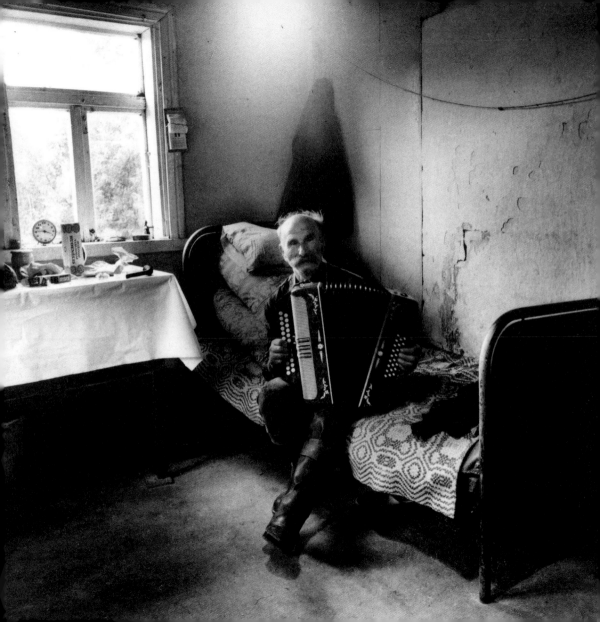

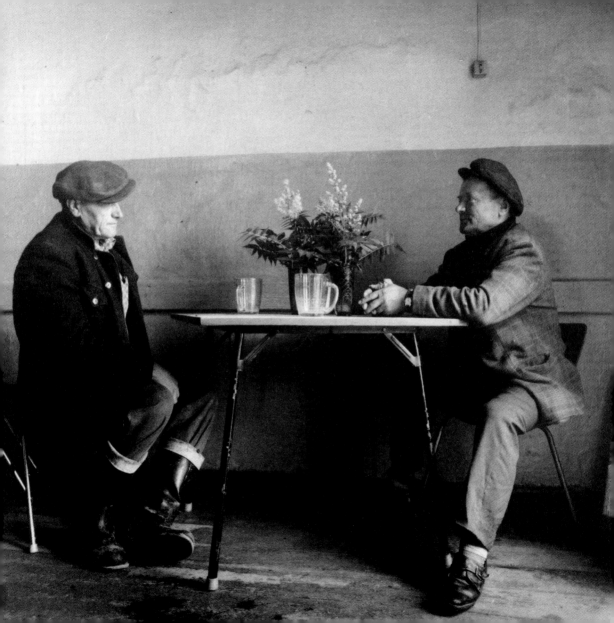

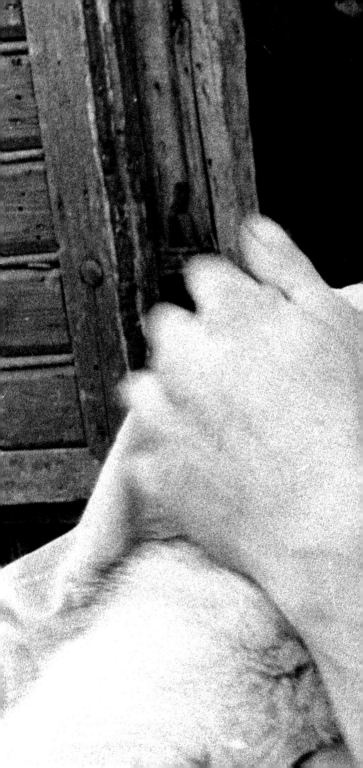

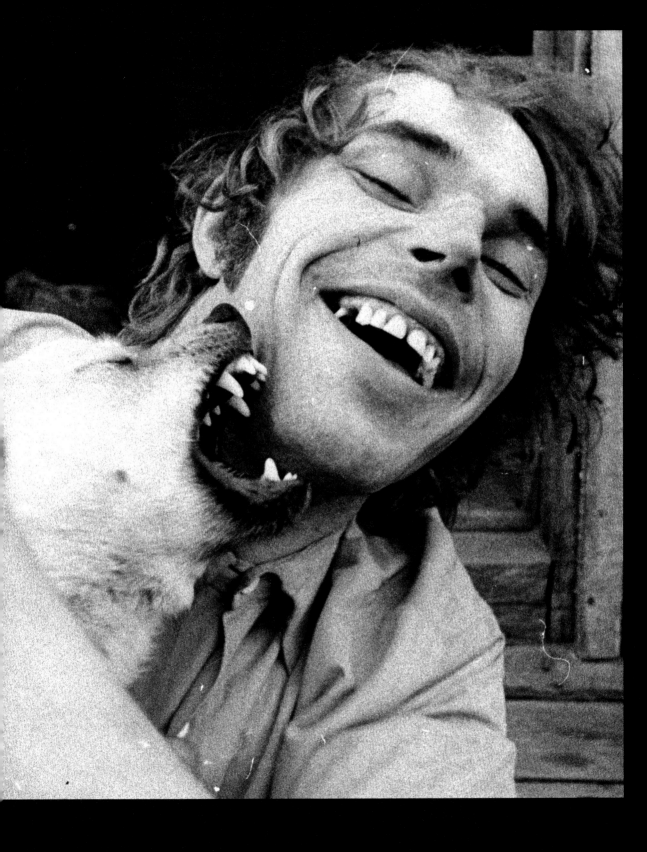

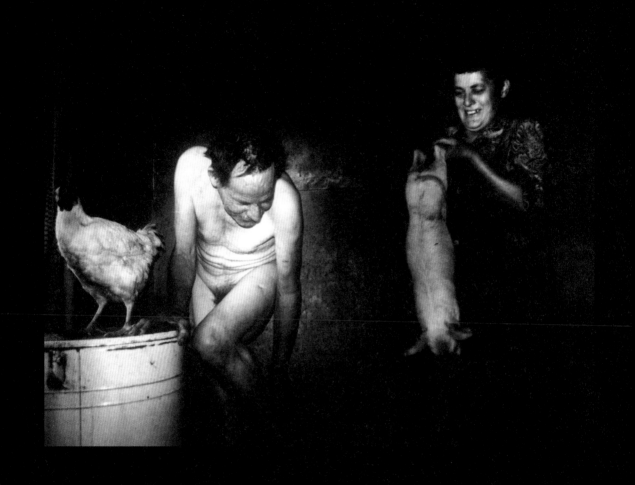

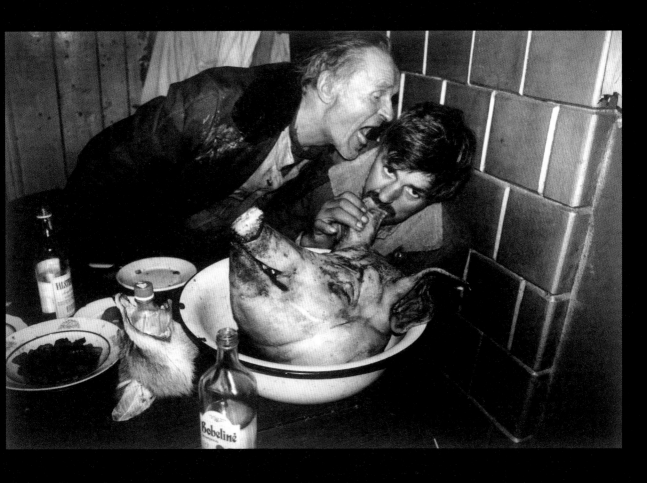

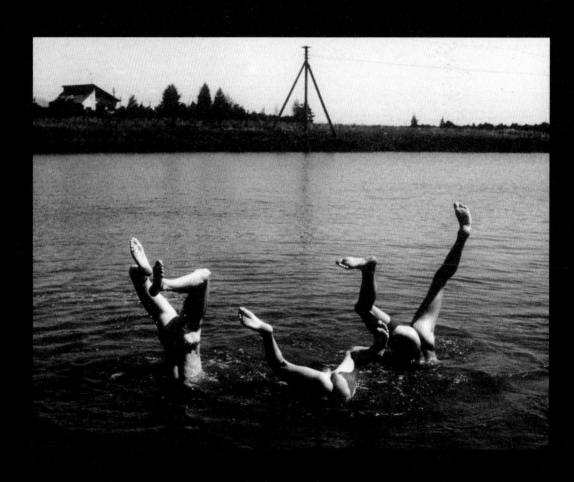

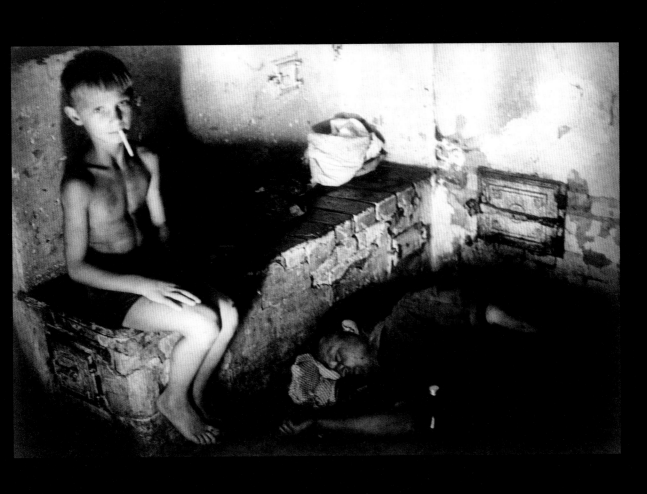

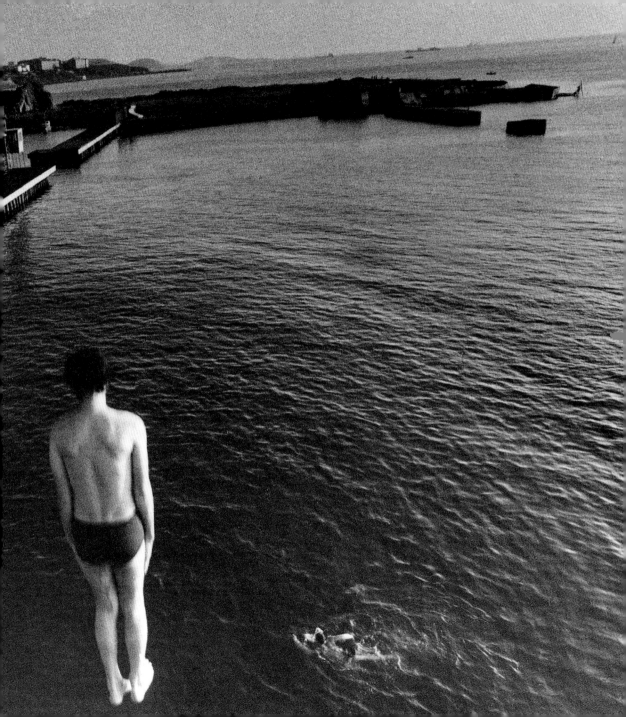

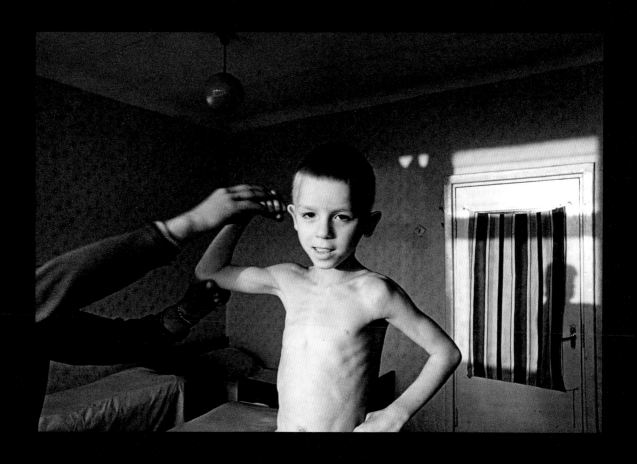

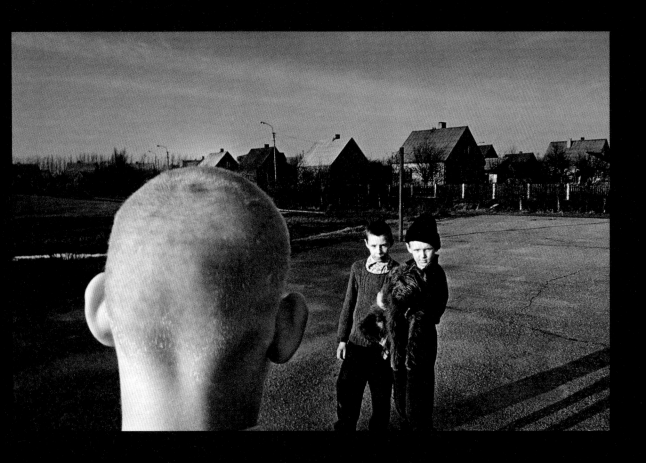

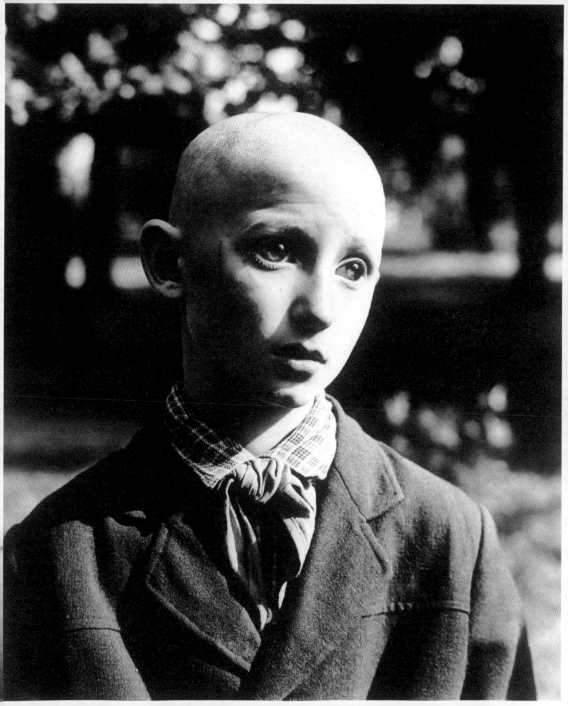

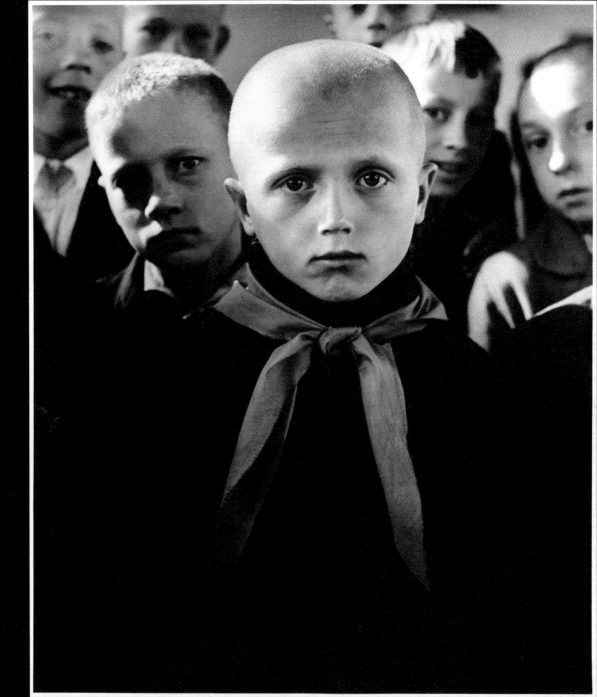

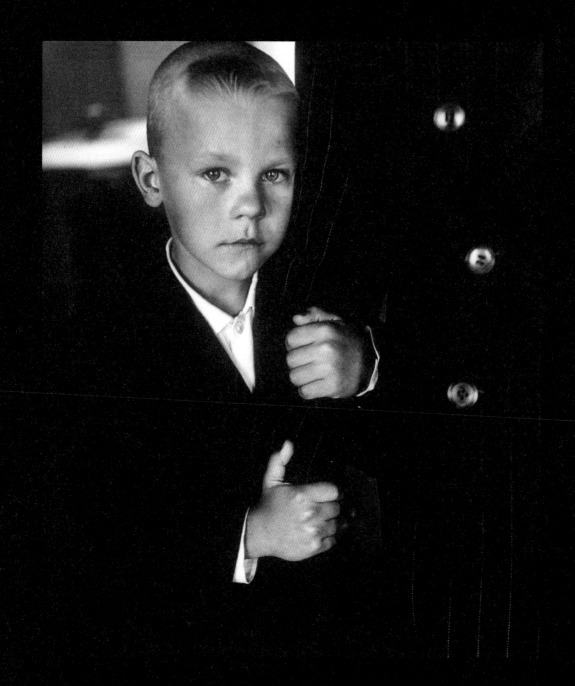

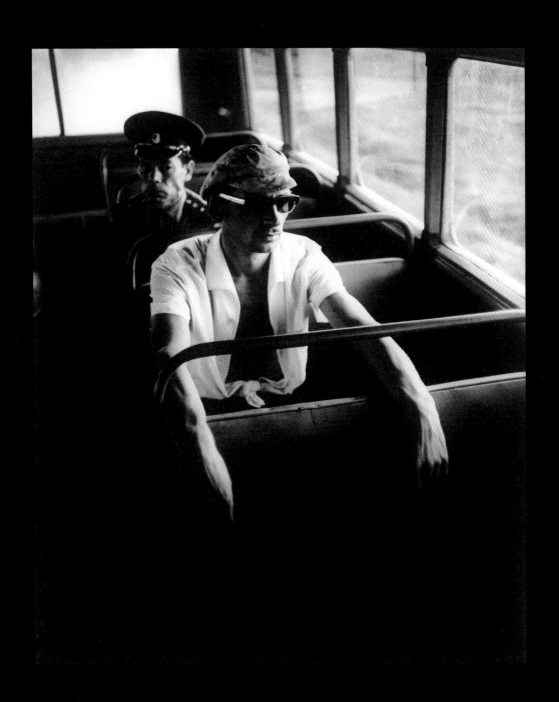

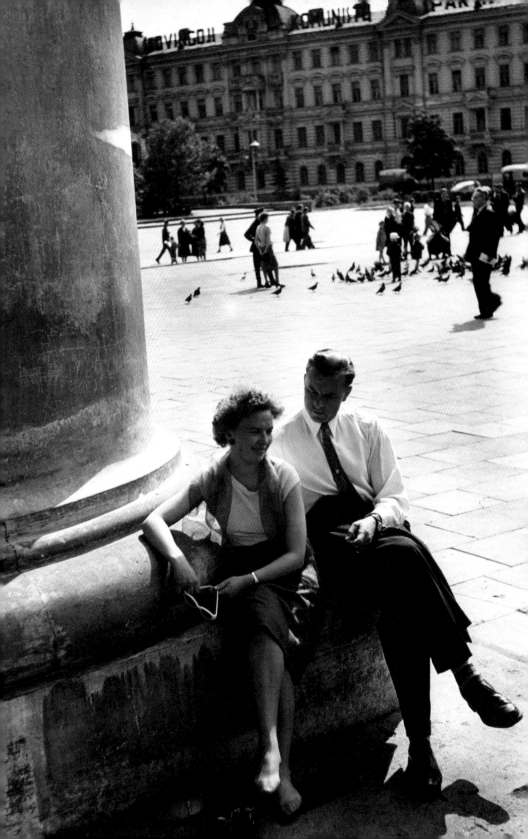

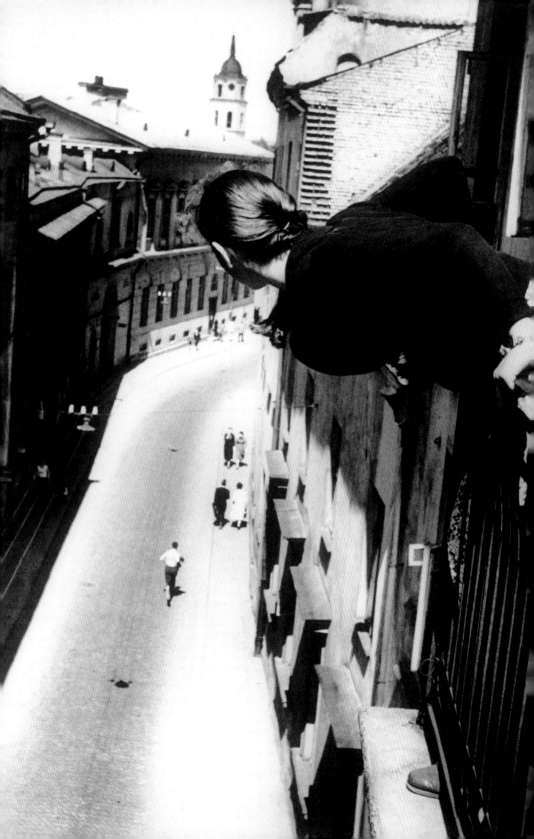

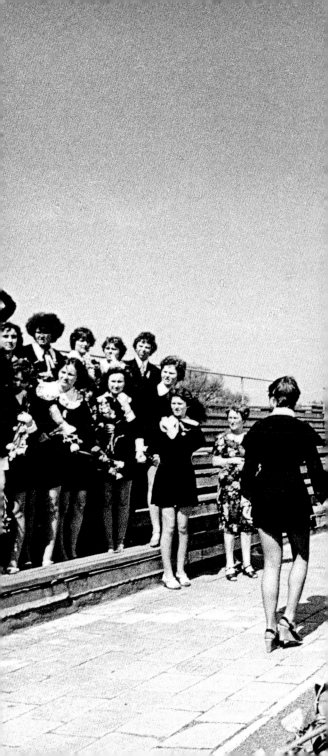

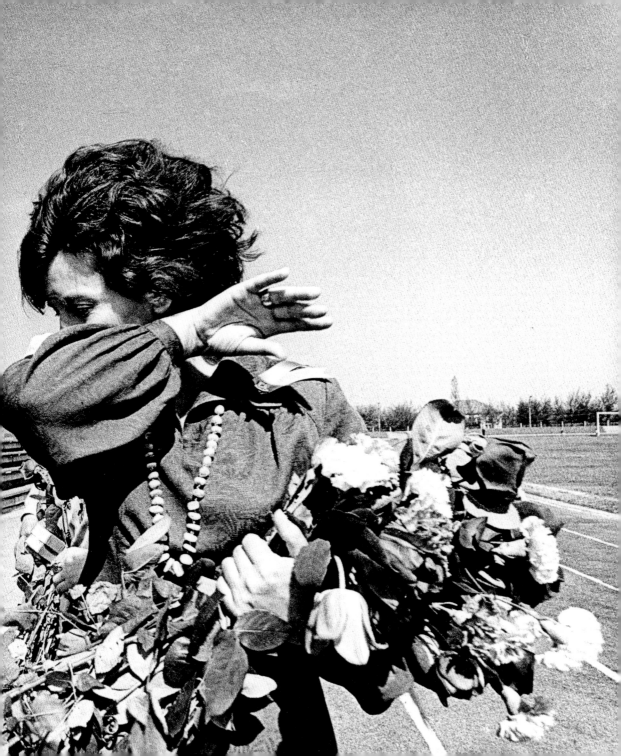

吉恩陶塔斯‧特里馬卡斯 ｜ Gintautas Trimakas

亞封薩斯‧布德維蒂斯 ｜ Alfonsas Budvytis

亞爾吉達斯‧赦斯庫斯 ｜ Algirdas Šeškus

維奧列塔‧布比立蒂 ｜ Violeta Bubelytė

金塔拉斯‧津克維丘斯 ｜ Gintaras Zinkevičius

羅馬斯‧尤斯克利斯 ｜ Romas Juškelis

雷米吉尤斯‧特雷吉斯 ｜ Remigijus Treigys

IDENTITY
AS
AN OBJECT

認同即物件

認同即
物件

1990 年代初露頭角的年輕一代攝影家，捨棄了前輩的人文主義攝影主題，開始透過物質性（materiality）與平庸（banality）的稜鏡審視日常生活。前一時期戲劇化、令人印象深刻的肖像和群像內容，已被這些年輕藝術家作品中寂靜的城市景觀和以破舊物品陳設、強調空缺的室內景觀所取代。攝影取材的主要對象不再是個人，而是人們周圍的環境。對影像本身的感知也有所改變：視覺和心理層面強烈的作品已被簡明的小幅影像取代。攝影界提升了對「業餘」美學的欣賞，似乎在暗示，沒有所謂失敗的鏡頭，而最大的錯誤就是試圖糾正失敗。此外，女性藝術家儘管時常被人以質疑的角度審視，仍步入了以男性為主體的攝影圈。也就是說，這一時期標誌著該國接近重獲獨立的社會轉變（改革重建政策、日益激烈的抵抗運動、群眾集會和示威），同時立陶宛攝影圈的變化更公開地規避了蘇聯當局對藝術的審查制度，並試圖將自己從傳統的表現法則中解放出來。

攝影家以受到蘇維埃無止境又全面治理下的疲弱之眼，來環顧其週遭現實；並未試圖掩飾那份疲憊和沮喪。他們將目光轉向最簡單的日常物件：浸泡在浴缸裡的海綿、骯髒的踏墊、滑落的襪子、處處皺褶的床單。創作者似乎試圖描繪日常環境中隱性的事物，即那些未被注意到、微不足道的物件。同樣地，這些作品中的自我感知是透過觸摸極度接近我們的事物而展開的——若它們被磨損或皺褶，會如何？這些攝影作品揭示了家庭作為社會最小單位的隱喻。家中的各個表面就像人類經驗的積累，它們記得曾經觸摸過、躺過、坐過、看過的人。

這些被拍攝的物件因此有了紀念意義，象徵著對個體性的無限渴望。渴望一個自由的地點、空間或時間。「在這些地方，你可以做想做的事、制定自己的規則、語無倫次或神秘莫測地說話、忘卻時間的存在、或無視最新的著裝守則。」[1]

藝術家開始審視個人與社會之間複雜的關係，質疑人類身分的完整性，強調其在時間脈絡中的脆弱和片段。這些作品以完全不同的取徑，重新思考這一時期的現實和個人在其中的位置。維奧列塔·布比立蒂（Violeta Bubelytė）、吉恩陶塔斯·特里馬卡斯（Gintautas Trimakas）、和亞封薩斯·布德維蒂斯（Alfonsas Budvytis）的作品中，攝影對象是「去人性化」的，它就只是一個物件。維奧列塔·布比立蒂反抗當時盛行的裸體攝影表現方式——「美麗的」女體相伴著自然景色。布比立蒂在作品中不把女性身體視為肉慾的視覺快感來源，而是作為表達各種存在狀態的工具，並透過特異的姿勢和各式物件，介入觀者對作品中人體通常會有的凝視過程。吉恩陶塔斯·特里馬卡斯（Gintautas Trimakas）的《軀幹—身體部位》以不顯示臉部的方式記錄了人體。這些照片中的服裝成為表達身分的方式，就如同制服指出了穿著者所屬的社會群體。穿著這些衣服的身體亦被去個人化、感官麻木，並被物化。相反地，羅馬斯·尤斯克利斯（Romas Juškelis）拍攝商店展示櫥窗裡的模特兒，讓它們看起來栩栩如生，再次強調（又或者總結）了當時的氛圍：無止境的限制，是無論如何也無法約束生活（命）的。

[1] J．瓦拉克維休斯，〈那裡與這裡〉，《現在與有時》（考納斯：Kitos Knygos 出版社，2009），頁 10。

IDENTITY
AS
AN OBJECT

The young generation of photographers, who made their artistic debuts in the 1990s, turned away from the humanistic themes developed by their predecessors and began to look at everyday life through the prism of materiality and banality. The impressive, dramatic portraits and multi-figure compositions have been replaced in the works of these young artists by hushed cityscapes and emphatically empty interiors with worn-out items. The main object of photography is no longer a person, but the environment around them. Perceptions of the image itself have also changed: visually and psychologically intense works have been replaced by simple small-format photographs. The appreciation of "amateur" aesthetics in photography increased, seeming to suggest that a failed shot did not exist, and the biggest mistake would be to correct it. In addition, female artists entered the almost exclusively male circle of photographers, although they were often viewed with skepticism. In other words, this period marks a change in society approaching the restoration of independence (the perestroika policy reforms, the intensifying resistance movement, mass rallies and demonstrations), and at the same time a change in Lithuanian photography which ever more openly circumvents the censorship of art by the Soviet authorities and tries to liberate itself from the rules of conventional representation.

Photographers look at their surroundings with the eyes of people exhausted from Soviet reality and constant regulation, without trying to hide that fatigue and frustration. Their gaze diverts to the simplest everyday objects: a sponge soaking in the bathtub, a dirty door mat, socks that have slipped down, a crumpled bedspread. The authors appear to be trying to portray the invisible, i.e. what remains unnoticed and insignificant, in the everyday environment. Similarly, self-perception in these works unfolds by touching the things which are infinitely close to us – so what if they are worn or crumpled? The photographs reveal the metaphor of home as the smallest part of society. Surfaces at home are like accumulations

of human experiences, they remember the people who have touched them, lain on them, sat on them, and looked at them. The depicted objects acquire a monumentality and symbolise the infinite longing for individuality. Longing for a place, space or time where you are free. "Places where you can do what you want to, where you can create your own rules, speak incoherently or mysteriously, forget the time and disregard the newest dress code." [1]

Artists began to examine the complex relationship between the individual and society, to question the integrity of human identity, to highlight its fragility and fragmentation in the context of time. The reality of this period and the place of a human in it are rethought in a completely different way. In the works of Violeta Bubelytė, Gintautas Trimakas, and Alfonsas Budvytis, the photographic subject is "dehumanised", it is simply one more object. Violeta Bubelytė, rebelling against the stereotype of "beautiful" women complementing nature that prevailed during that period in nude photography, treats the woman's body not as a source of erotic visual pleasure, but as a tool to express various states of being and interferes with the usual journey of the viewer's gaze at the depicted body through the use of unusual poses and various objects. Gintautas Trimakas' series *Torso – Body Part* documents people without showing their faces. Clothing in these photographs becomes an expression of identity, which, like a uniform, suggests the social group that the person belongs to, and the bodies wearing these clothes become deindividualised, desensitised, and objectified. Romas Juškelis, in contrast, captures static mannequins in shop windows, bringing them to life and emphasising (or perhaps summarising) the mood of the time once more: constant constraints which cannot in any way constrain life itself.

[1] Valatkevičius. J., *There and Here. Now and Sometime [Miestas Kitaip]*, ed. M. Matulytė, Kaunas: Kitos Knygos, 2009, p. 10.

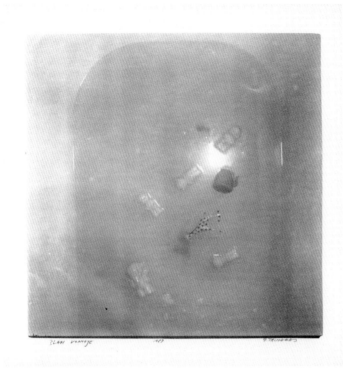

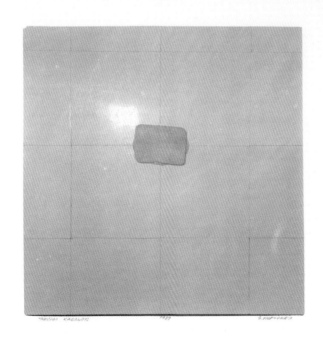

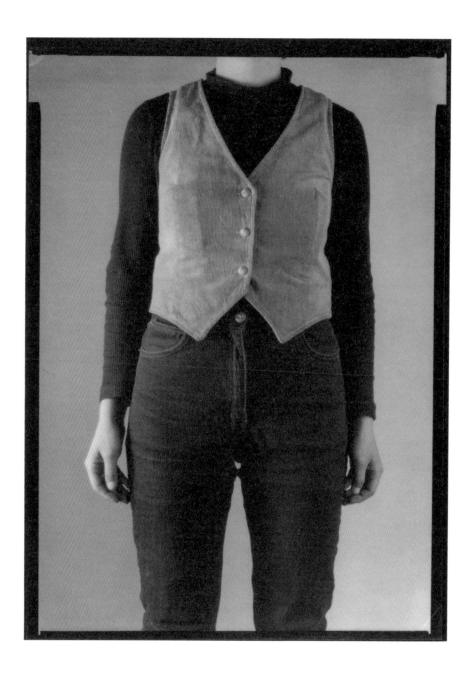

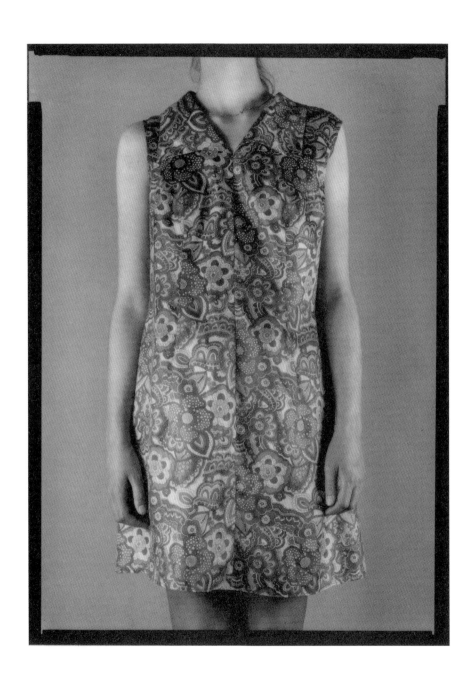

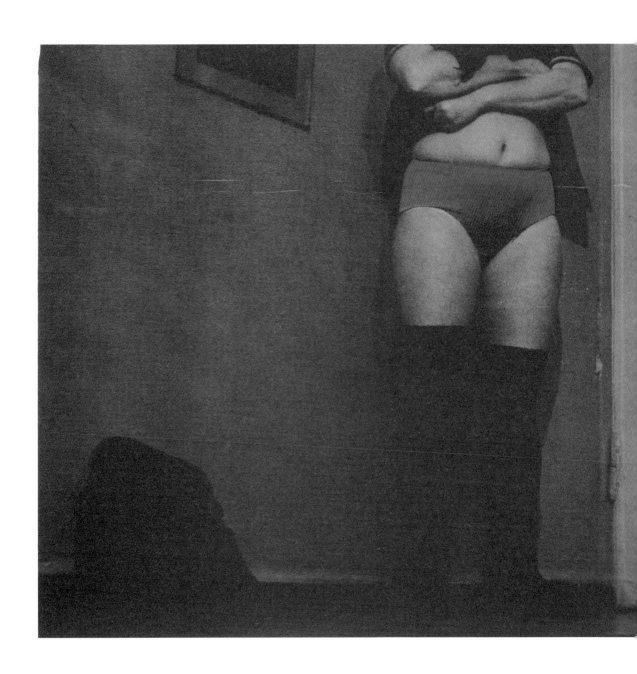

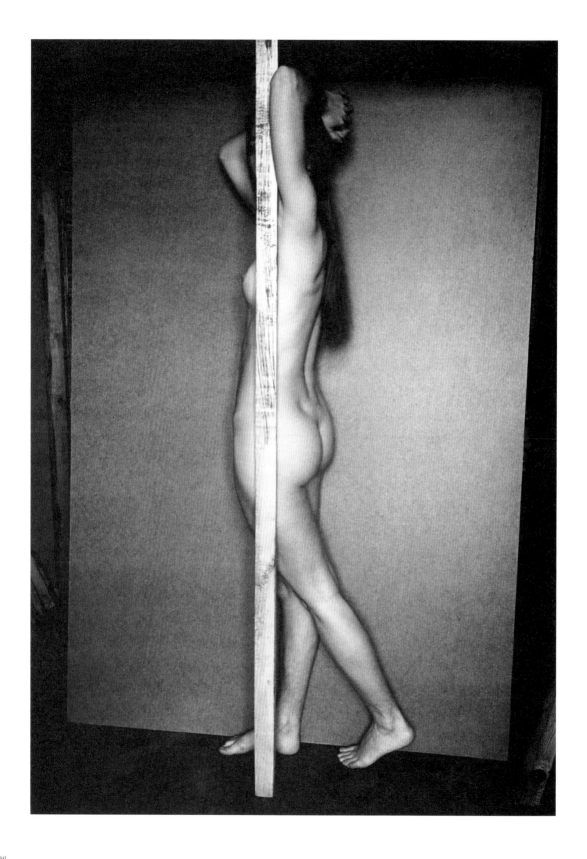

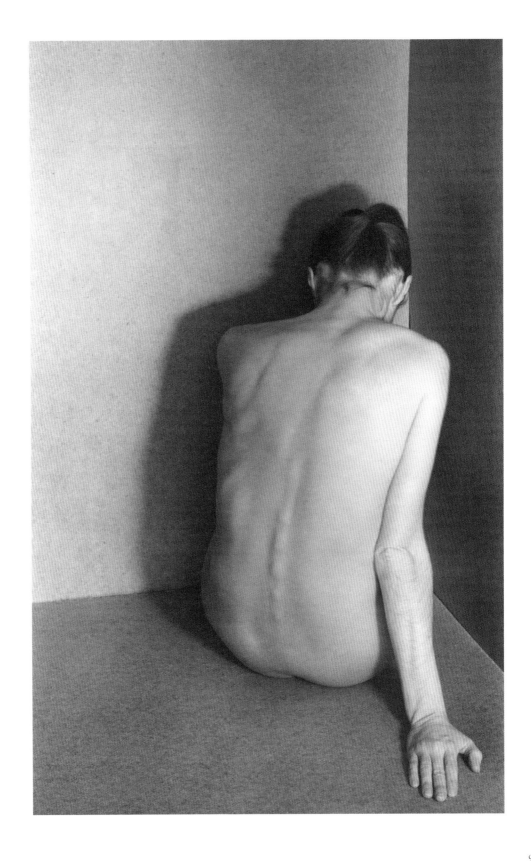

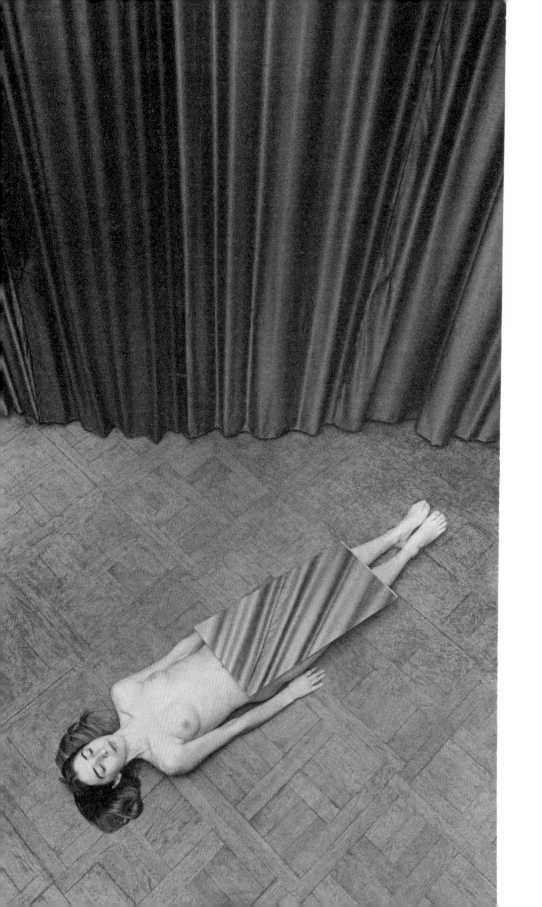

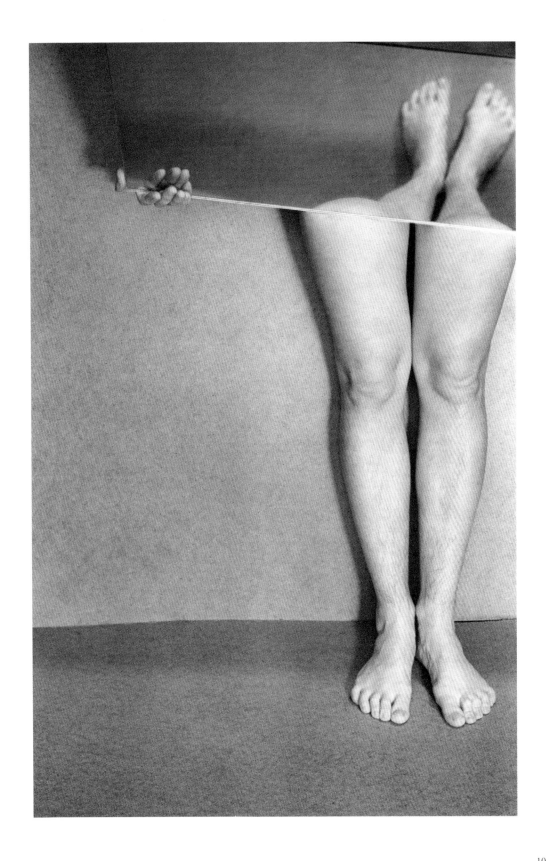

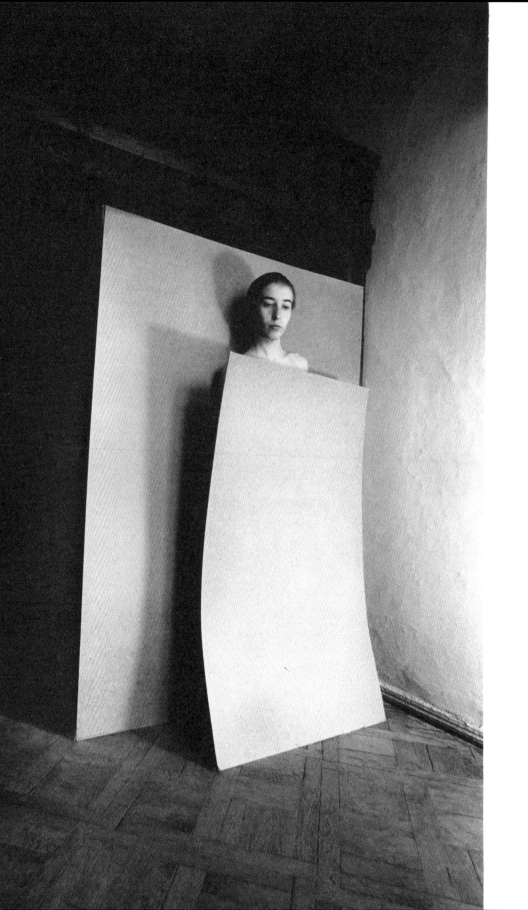

Nuotrauka

Slenkstis

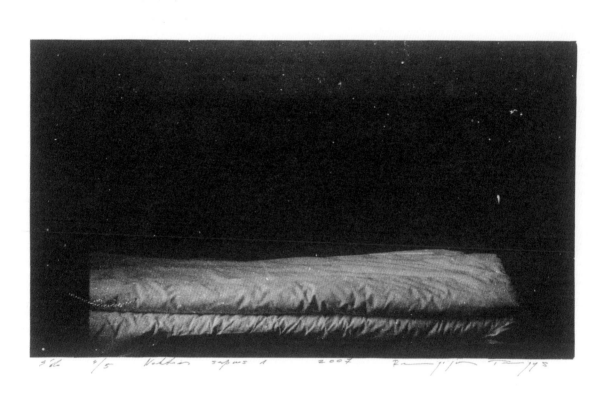

8/10 4/5 Voltron sapins 1 2007 Ramijini Tanya JS

3'6 3/3 Notturno soprano 2 2007

勞拉・加布施蒂恩 ｜ Laura Garbštienė

捷斯特・瑪莉亞・欽辛奈迪特 ｜ Geistė Marija Kinčinaitytė

多維立・達吉恩尼 ｜ Dovilė Dagienė

塔達斯・卡扎克維丘斯 ｜ Tadas Kazakevičius

亞克維立・安格立凱德 ｜ Akvilė Anglickaitė

IDENTITY AS A CONCEPT

認同即概念

認同即
概念

20 世紀末標誌了立陶宛攝影的新變革。成立於 1997 年的維爾紐斯藝術學院（Vilnius Academy of Arts）攝影與媒體藝術系是第一所相關的高等教育機構，培養了一整世代的年輕藝術家，而這些青年創作者對立陶宛攝影復興有著顯著貢獻。科技發展和數位攝影的興起，使攝影成為當代藝術中重要的一部份。隨著全球藝術場域的開放，各地藝術圈大量吸收不同脈絡文化，攝影（或者說以攝影為媒材的藝術創作）變得十分多元。談論當今攝影（或者藝術）的趨勢並不是件容易的事，不僅是因為近期發生的事件幾乎使整個世界停擺，並從根本上改變了我們的正常生活；更是因為，在無法依賴時間流逝所提供的「安全」距離下，評鑑當代藝術成為一項挑戰、一場試圖預知未來的有趣實驗。

藝術家在其作品中以不同的形式分析各種當代進程，及其與過去的關係。他們將身分認同的概念發展為非固定、持續變化的社會實體。攝影經常成為探討個人與社會的關係之對話平台，驅使人們反思更廣泛層面的存有和當代人類經驗。透過運用各種研究策略，藝術家似乎不再追求客觀性記錄，他們不再聲稱揭示「真相」，而是以破壞和解構看似理所當然、穩定不變的事物為目標。

在全球文化視覺化、影像過剩及不斷擴生的脈絡下，藝術家突顯了攝影（更廣泛地說，影像）與身分認同之間充滿疑慮的關係。亞克維立·安格立凱德（Akvilė Anglickaitė）在其攝影作品中運用了基督教藝術中聖母的圖像學傳統。她以寵物取代聖母懷中的嬰兒，批評既定的家庭刻板印象，提出了一個「神聖」的替代方案。勞拉·加布施蒂恩（Laura Garbštienė）的作品則以（自我）嘲諷的方式重新塑造了認知。加布施蒂恩的《我該怎麼做才能讓獨角獸把頭靠在我的腿上？》系列參照了描繪獨角獸狩獵場景的中世紀掛毯。她結合攝影和表演實務，挑戰以神話為基礎的價值觀，論證「處女和獨角獸不可能相遇」的可能性。就像愛麗絲尾隨白兔一樣，藝術家透過創造新的攝影現實來挑戰影像使用習慣，誘使觀眾跟隨他們進入「仙境」——愛麗絲想著：「好吧！我常看見臉上沒有笑容的貓；但從沒見過僅有咧開的嘴卻不見貓的景象！這是我這輩子見過最奇特的事了！」[1]

藝術家透過紀實攝影的方式，不斷地重新思考他們所傳達資訊的局限性。捷斯特·欽辛奈迪特（Geistė Kinčinaitytė）在其充滿爭議的《你屬於我》系列中，透過科技創造的圖像跟情感和直覺互動。該系列的內容包含了美國太空總署（NASA）好奇號探測車所拍攝的火星表面照面。這顆行星的礫石高原、裂開的隕石坑和位於照片一側的探測車車體令人感到畏懼——因為觀者知道正在觀看的事物如此陌生，卻又如此逼近自己。藝術家企圖尋找火星與地球地景間的相似之處，並將我們對自身星球憧憬的凝視擬人化，彷彿這個擬人化的凝視具有意識，知道火星與地球兩者永遠不會相遇，儘管兩者會像崔斯坦和伊索德、奧菲斯和尤莉提或其他成千上百個無法圓滿的愛情故事，接近卻無法相交。塔達斯·卡扎克維丘斯（Tadas Kazakevičius）在作品《即將消逝》中，將蒐集來的影像視為檔案，並捕捉村莊及當地社群的影像。他觀察不斷改變的傳統，反思人口變遷，在陌生的他者日常生活中尋覓熟悉的元素。透過捕捉正在消失中的現象，藝術家分析身分認同的脆弱與波動，並觀察人們的身分認同在外部影響下如何隨時間變化。時間維度在多維立·達吉恩尼（Dovilė Dagienė）的《植物記憶》系列中亦是重要元素，使其發展出了猶太文化遺產的主題。透過捕捉現存的木造猶太教堂和那些生長在其週圍、見證了歷史變遷的植物，藝術家重新思考集體記憶（或後記憶）的相關性。而現在和過去之間的張力在銀鹽攝影中被放大了出來。因此，年輕世代的藝術家無論創作方向有多麼不同，都因對攝影這媒材的關注而團結了在一起。透過概念化各種攝影過程，藝術家在每次的拍攝中都又重新認識了攝影藝術。

[1] 路易斯 · 卡羅，《愛麗絲夢遊仙境》（芝加哥：第一輯出版社，1998），頁 94。

A CONCEPT

The turn of the century marked new changes in Lithuanian photography. The photography and Media Art Department at the Vilnius Academy of Arts, established in 1997, became the first higher education institution to train a whole generation of young artists who significantly contributed to the renewal of Lithuanian photography. The development of technology and the emergence of digital photography have led it to become a major part of contemporary art. As the global art field opened up and the local art scene greedily absorbed different contexts, photography (or rather, art based on the medium of photography) became very diverse. This means that it is not easy to talk about today's trends in photography (and art in general), and not only because of the recent events that have brought almost the entire world to a halt and radically changed our normal lives. Assessing contemporary art without the "safe" distance provided by the passage of time becomes a challenge, an interesting experiment in trying to foretell the future.

In their works, artists analyse various contemporary processes and their relationship to the past in different forms. They develop the idea of identity as an unstable, changing social entity. Photography often becomes a platform for dialogue about the relationship between the individual and society, and an incentive to reflect on the broader aspects of being and contemporary human experience. By applying research strategies, artists do not seem to seek objective documentation, they no longer claim to reveal the "truth", but rather aim to destabilise and deconstruct what has seemed self-evident and unchanging.

In the context of global cultural visualisation, the excess of images and their constant proliferation, artists highlight the problematic relationship between photography (more broadly, image) and identity. Akvilė Anglickaitė brings the iconography of the Mother of God from religious art into her photographs. By replacing the baby with pets she criticises the established stereotypes of the family and presents a "divine" alternative. The works of Laura Garbštienė (auto)ironically reformulate the aspect of cognition. In the cycle *What Should I Do so That the Unicorn Would Come and Lay Its Head on My Lap?* Garbštienė refers to a series of medieval tapestries which depict unicorn hunting. Combining photography and performance practices, she raises the issue of myth-based values and argues for the possibility of the impossibility of the meeting of a virgin and a unicorn. Like Alice following the White Rabbit, the artists lure the viewer to follow them into Wonderland by

creating a new photographic reality that challenges the habits of image use: "Well! I've often seen a cat without a grin", thought Alice, "but a grin without a cat! It's the most curious thing I ever saw in all my life!" [1]

Through the use of documentary photography strategies, artists constantly rethink the limitations of the information it conveys. In Geistė Kinčinaitytė's controversial series *You Belong to Me,* images created by technology interact with feelings and intuition. The series includes photographs of the surface of Mars taken by NASA's rover Curiosity. The planet's gravel plateau, gaping craters, and part of the rover visible on one side of the photograph are frightening, knowing that you are watching something that is so frighteningly unfamiliar, but at the same time so close. The artist is searching for parallels between the landscapes of Mars and Earth and personifies the longing gaze of our planet, as if it realises that they will never be together, although they will stay close forever like Tristan and Isolde, Orpheus and Eurydice or hundreds of other unfulfilled love stories. Tadas Kazakevičius collects images as documents and captures villages and their communities in his series *Soon To Be Gone.* He observes changing traditions, reflects demographic changes, and searches for familiar elements in the daily lives of unfamiliar people. By capturing vanishing phenomena, the artist analyses the fragility and volatility of identity, and observes how it changes over time under external influences. The dimension of time is also important in Dovilė Dagienė's series *Plant Memory,* which develops the theme of Jewish cultural heritage. By capturing the surviving wooden synagogues and the plants growing on or around them that have become witnesses of a fading historical memory, the artist reconsiders the relevance of collective memory, or postmemory. The tension between the present and the past is amplified by the use of analog photography. Thus, the young generation of artists, no matter how different their creative directions, are united by their focus on the medium of photography itself. By conceptualising various photographic processes, they rediscover photography each time anew.

[1] Carroll L., *Alice's Adventures in Wonderland,* Chicago: Volume One Publishing, 1998, p. 94.

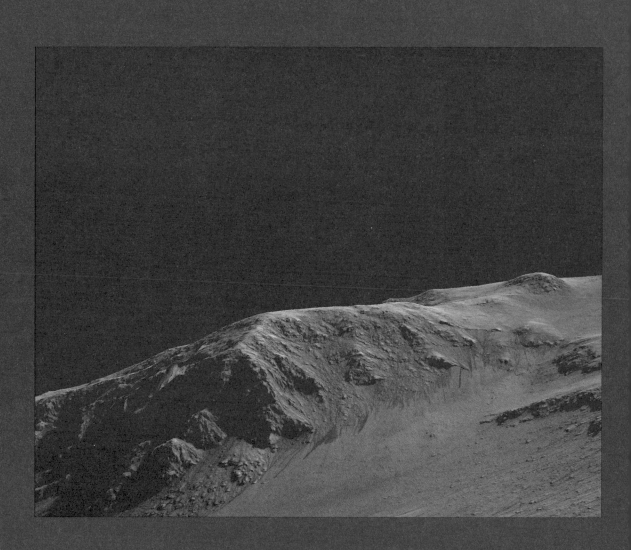

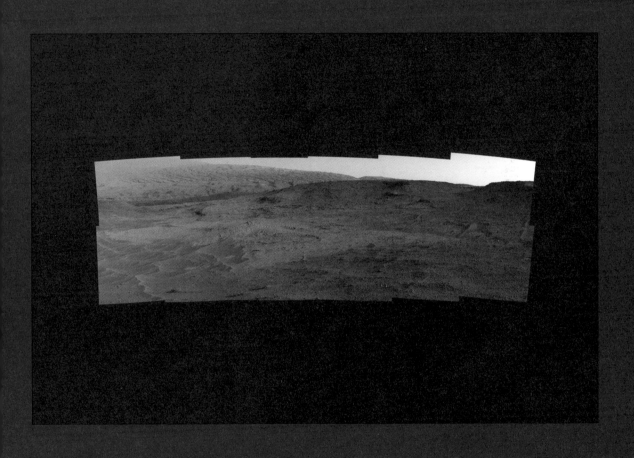

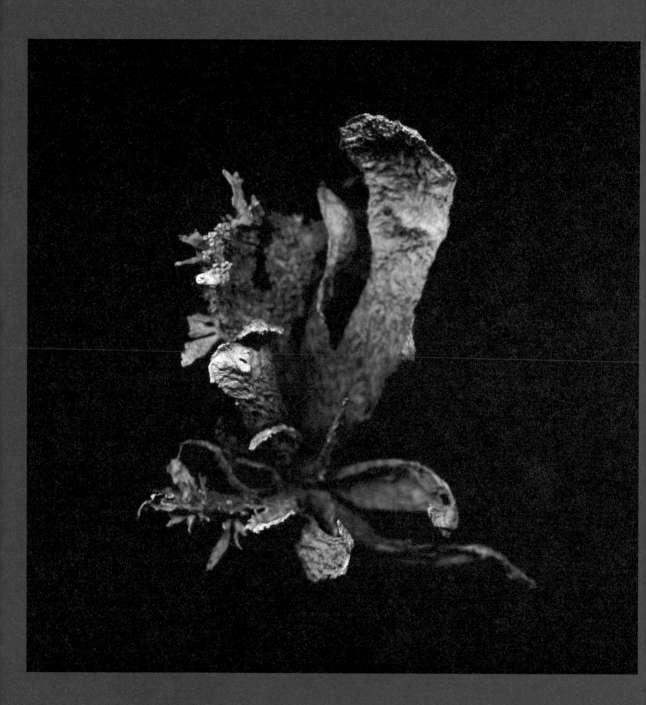

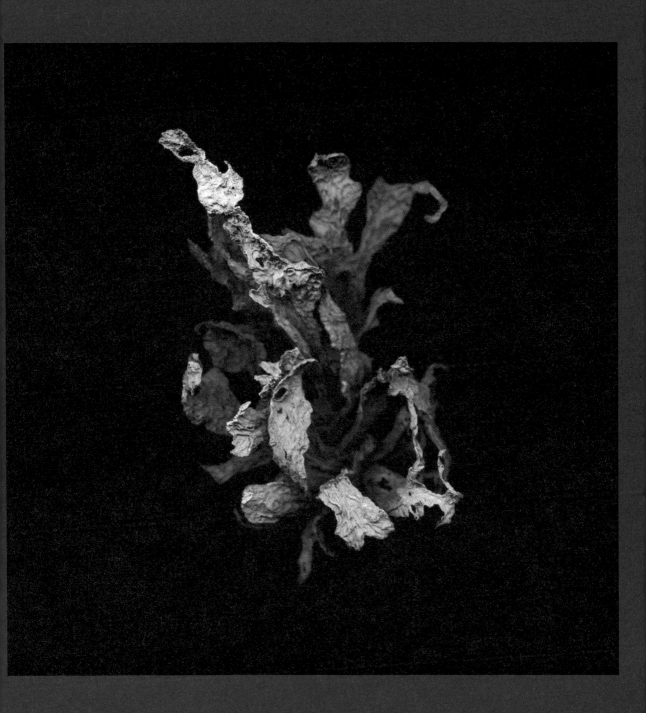

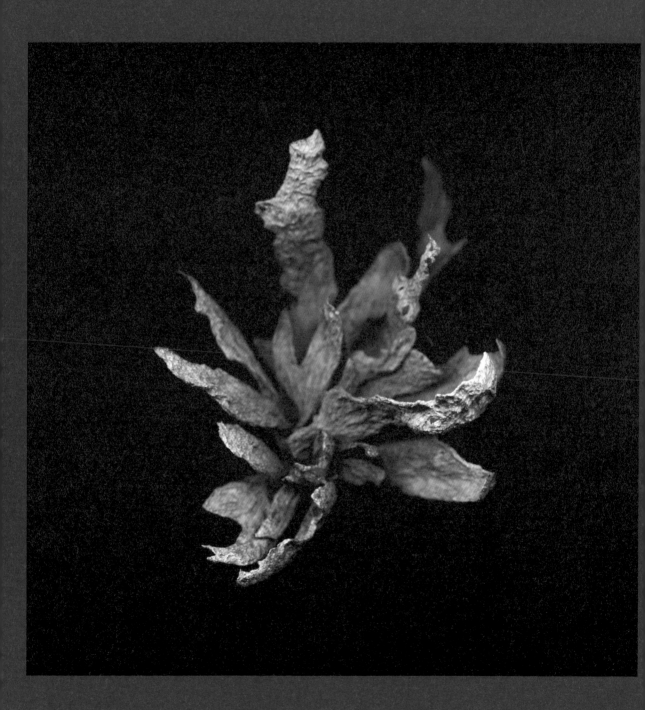

ARTISTS' INTRODUCTIONS AND CAPTIONS

藝術家簡介與圖說

羅穆豪達斯・拉考斯卡斯（1941-）

《盛放》是拉考斯卡斯最重要及最著名的系列。在 1974 到 1984 的十年間，拍攝春季花期的立陶宛村莊風光。這組作品創造出抒情、甚至感傷的影像，表達對日常生活樂觀、美好的願景；以隱喻的方式表達人與自然之間的關係，並封存人類存在的核心價值。

Romualdas Rakauskas (b. 1941)

Blooming is the most significant and well-known cycle of photographs by Rakauskas. The cycle, which took a decade to create (1974–1984), captures Lithuanian villages during the spring flowering. The photographs create lyrical, even sentimental images, expressing an optimistic, bright vision of everyday life, speak metaphorically about the relationship between humans and nature, and encapsulate the fundamental values of human existence.

p. 29

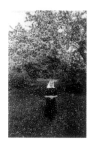

〈盛放，第 12 號〉
Blooming, No. 12
1975
明膠銀鹽相紙
Gelatin silver print
39.2 × 24.9cm
立陶宛國家美術館藏
Collection of the
Lithuanian National Museum of Art

p. 30

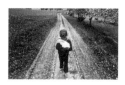

〈盛放，第 49 號〉
Blooming, No. 49
1976
明膠銀鹽相紙
Gelatin silver print
24.9 × 39.1cm
立陶宛國家美術館藏
Collection of the
Lithuanian National Museum of Art

p. 32

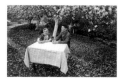

〈盛放，第 4 號〉
Blooming, No. 4
1975
明膠銀鹽相紙
Gelatin silver print
24.9 × 39.1cm
立陶宛國家美術館藏
Collection of the
Lithuanian National Museum of Art

p. 33

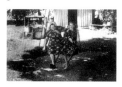

〈盛放，第 72 號〉
Blooming, No. 72
1978
明膠銀鹽相紙
Gelatin silver print
24.9 × 39.1cm
立陶宛國家美術館藏
Collection of the
Lithuanian National Museum of Art

亞歷山德拉斯・馬西豪斯卡斯（1938-）

馬西豪斯卡斯的現代美學以紀實和報導攝影原則為基礎，其作品以社會議題、獨特少見的角度和富有表現力的特寫鏡頭為大宗。《立陶宛鄉村市集》（1968-1987）是其最著名的系列作品之一。在該作品中，藝術家拍出了鄉村市集上未加修飾的混亂，展露出每位拍攝對象的心理狀態。其帶著諷刺的凝視，與善於捕捉日常生活中戲劇性事件的敏銳目光，兩者矛盾地共存著。

Aleksandras Macijauskas (b. 1938)

Macijauskas' modern aesthetic is based on the principles of documentary and reporting photography. His work is dominated by social themes, unexpected angles, and expressive close-ups. One of his most famous series is *Lithuanian Rural Markets* (1968–1987) in which the psychology of individual subjects unfolds against the unadorned chaos of rural markets. His ironic gaze paradoxically coexists with a keen eye for the drama to be found within everyday life.

p. 34

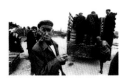

〈鄉村市集，第 108 號〉
In the Rural Market, No. 108
1975
明膠銀鹽相紙
Gelatin silver print
25.6 × 39.1cm
立陶宛國家美術館藏
Collection of the
Lithuanian National Museum of Art

p. 36

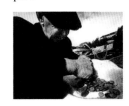

〈鄉村市集，第 120 號〉
In the Rural Market, No. 120
1975
明膠銀鹽相紙
Gelatin silver print
29.1 × 37.5cm
立陶宛國家美術館藏
Collection of the
Lithuanian National Museum of Art

p. 38

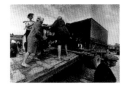

〈鄉村市集，第 132 號〉
In the Rural Market, No. 132
1974
明膠銀鹽相紙
Gelatin silver print
27 × 38.8cm
立陶宛國家美術館藏
Collection of the
Lithuanian National Museum of Art

p. 41

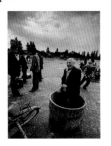

〈鄉村市集，第 149 號〉
In the Rural Market, No. 149
1976
明膠銀鹽相紙
Gelatin silver print
38.4 × 28.9cm
立陶宛國家美術館藏
Collection of the
Lithuanian National Museum of Art

亞吉曼塔斯 · 昆丘斯（1939- ）

昆丘斯的作品以肖像和風景形式呈現的人物攝影為主。作品中人物含蓄保留的神情加上影像細微的階調變化為其特徵。這些照片因它們周延的思考方式與對日常生活現象觀看角度，而顯得與眾不同。《星期天》為他最著名的系列之一，拍攝立陶宛村落、沿海城鎮民眾參與教會節日活動和的身影。這組作品從社會人類學的角度觀察鄉村民眾，記錄他們與環境的關係和連結。由於涉及宗教內容，該系列在蘇聯時期遭受審查。

Algimantas Kunčius (b. 1939)

Kunčius' work focuses on figurative photographs in both portrait and landscape formats. Their reserved expression is characterised by a subtle gradation of tones. Kunčius' photographs stand out for their thoughtfulness and philosophical approach to everyday phenomena. *Sundays* is one of his most famous series, immortalising the participants of church holidays and feasts in Lithuanian villages and coastal towns. It observes rural people from a socio-anthropological perspective, recording their relationships and connections with the environment. The series was censored during the Soviet era due to its religious content.

p. 42

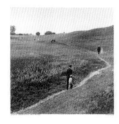

〈星期天，第 1 號〉
Sundays, No. 1
1968
明膠銀鹽相紙
Gelatin silver print
26 × 25.9cm
立陶宛國家美術館藏
Collection of the
Lithuanian National Museum of Art

p. 43

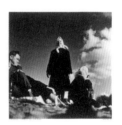

〈星期天，第 6 號〉
Sundays, No. 6
1969
明膠銀鹽相紙
Gelatin silver print
26 × 25.6cm
立陶宛國家美術館藏
Collection of the
Lithuanian National Museum of Art

p. 44

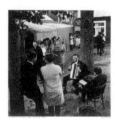

〈星期天，第 7 號〉
Sundays, No. 7
1969
明膠銀鹽相紙
Gelatin silver print
26 × 25.8cm
立陶宛國家美術館藏
Collection of the
Lithuanian National Museum of Art

p. 45

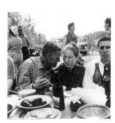

〈星期天，第 8 號〉
Sundays, No. 8
1969
明膠銀鹽相紙
Gelatin silver print
26 × 25.8cm
立陶宛國家美術館藏
Collection of the
Lithuanian National Museum of Art

p. 46

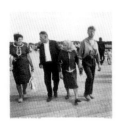

〈星期天，第 10 號〉
Sundays, No. 10
1969
明膠銀鹽相紙
Gelatin silver print
26.1 × 26cm
立陶宛國家美術館藏
Collection of the
Lithuanian National Museum of Art

p. 47

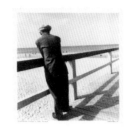

〈星期天，第 14 號〉
Sundays, No. 14
1969
明膠銀鹽相紙
Gelatin silver print
25.9 × 25.1cm
立陶宛國家美術館藏
Collection of the
Lithuanian National Museum of Art

羅穆豪達斯‧波澤斯基斯（1951- ）

波澤斯基斯的攝影作品結合了紀實與探究拍攝對象心理狀態的欲望，探索個人和集體身分認同的各種表現形式，並時常觸及社會議題。《朝聖》（1974-2001）是他最重要的作品之一。這系列呈現二十多年來，波澤斯基斯前往立陶宛各地旅行時，所拍攝到的宗教節日景象。那些如今正在消失的宗教儀式，在這系列中定格成永恆。波澤斯基斯藉由創作人物肖像、日常活動、民俗文化、建築和自然元素，對立陶宛日常生活進行多重反思。

Romualdas Požerskis (b. 1951)

In his photography, Požerskis combines a documentary gaze with a desire to investigate the psychology of his subjects, in order to explore various manifestations of individual and collective identity, often including social themes. One of his most important series is *Pilgrimages* (1974–2001). Over the course of more than two decades, Požerskis captured religious holidays as he travelled through the different regions of Lithuania. The works in this cycle immortalise the now disappearing rituals of communities. Multi-layered reflections of Lithuanian everyday life are created from the portraits of people, daily activities, folk culture, architecture, and natural elements.

p. 48

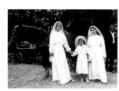

〈朝聖〉
Pilgrimages
1977
明膠銀鹽相紙
Gelatin silver print
22.7 × 32.6cm
立陶宛國家美術館藏
Collection of the
Lithuanian National Museum of Art

p. 50

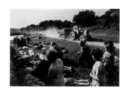

〈朝聖，第 79 號〉
Pilgrimages, No. 79
1978
明膠銀鹽相紙
Gelatin silver print
22.7 × 33cm
立陶宛國家美術館藏
Collection of the
Lithuanian National Museum of Art

p. 51

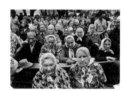

〈朝聖，第 155 號〉
Pilgrimages, No. 155
1989
明膠銀鹽相紙
Gelatin silver print
22.7 × 32.7cm
立陶宛國家美術館藏
Collection of the
Lithuanian National Museum of Art

p. 52

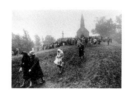

〈朝聖，第 162 號〉
Pilgrimages, No. 162
1982
明膠銀鹽相紙
Gelatin silver print
22.7 × 32.7cm
立陶宛國家美術館藏
Collection of the
Lithuanian National Museum of Art

p. 53

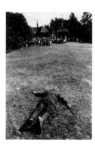

〈朝聖，第 187 號〉
Pilgrimages, No. 187
1983
明膠銀鹽相紙
Gelatin silver print
32.7 × 22.7cm
立陶宛國家美術館藏
Collection of the
Lithuanian National Museum of Art

維塔斯・呂克斯（1943-1987）

儘管呂克斯屬於依循人文攝影傳統創作的世代，其作品在早期便已脫離了人文攝影，逐漸轉向觀念攝影。雖為立陶宛攝影協會的成員，但由於呂克斯拒絕跟隨當時盛行的創作風格，和其離經叛道的態度，使他的作品在蘇聯時期並未廣泛傳播。呂克斯的作品系列為藝術攝影和紀實影像的結合，期許忠實地傳達情感和現實經驗。其《親戚》系列（1958-1987）捕捉了親人簡單樸素的日常生活，讓我們瞥見人類存在的意義。

Vitas Luckus (1943–1987)

Although he belonged to the generation of photographers who worked in the tradition of humanist photography, Luckus moved away from it early on in his work and turned towards conceptual photography. He was a member of the Lithuanian Photography Society, but his works were not widely disseminated during the Soviet era because of his refusal to conform to the prevailing photographic style and his rebellious attitude. He created photographic cycles characterised by the connection of artistic and documentary images and the desire to authentically convey emotions and the experience of reality. In the series *Relatives* (1958–1987), he captures the simple and unadorned everyday life of his loved ones, giving us glimpses into the meaning of human existence.

p. 54

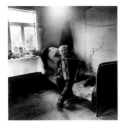

〈執手風琴〉
With a Bayan
1979
明膠銀鹽相紙
Gelatin silver print
23.9 × 23.5cm
立陶宛國家美術館藏
Collection of the
Lithuanian National Museum of Art

p. 55

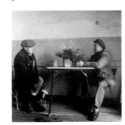

〈叔叔伯伯〉
Uncles
1979
明膠銀鹽相紙
Gelatin silver print
23.4 × 23.6cm
立陶宛國家美術館藏
Collection of the
Lithuanian National Museum of Art

p. 56

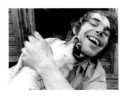

〈尤奧扎斯〉
Juozas
1975
明膠銀鹽相紙
Gelatin silver print
20.4 × 28.7cm
立陶宛國家美術館藏
Collection of the
Lithuanian National Museum of Art

瑞莫達斯・維克史雷蒂斯（1954-）

維克史雷蒂斯遵循立陶宛攝影的時代精神拍攝鄉村人物，然而其作品呈現了一種獨特、甚至激進的地方生活觀。他的拍攝對象多半來自社會邊緣。在其捕捉他們貧困生活的同時，他仔細處理畫面，並不迴避在作品中呈現諷刺或醜怪的景象；但同時，他也與拍攝對象保持著真誠、具同理心的關係。維克史雷蒂斯富有表現力的作品呈現了正在消逝的鄉村日常，並傳達出當地複雜的社會現實。

Rimaldas Vikšraitis (b. 1954)

Vikšraitis followed the Lithuanian photographic zeitgeist in focusing on rural people, but his photographs offer a unique and even radical view of life in the provinces. The subjects he captures are on the margins of society, and, as he immortalises their poverty-stricken lives, Vikšraitis sets the scene carefully; he does not avoid irony or the grotesque, but at the same time maintains a sincere, empathetic relationship with his subjects. His expressive photographs captivatingly reveal the vanishing everyday life of the countryside and describe its complex social realities.

p. 58

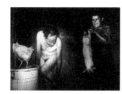

〈疲憊村民的怪相〉
Grimaces of the Weary Village
1998
明膠銀鹽相紙
Gelatin silver print
27 × 36cm
立陶宛國家美術館藏
Collection of the
Lithuanian National Museum of Art

p. 59

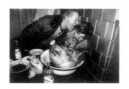

〈疲憊村民的怪相〉
Grimaces of the Weary Village
1999
明膠銀鹽相紙
Gelatin silver print
19.8 × 30cm
立陶宛國家美術館藏
Collection of the
Lithuanian National Museum of Art

p. 60

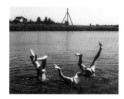

〈SOS —求救〉
SOS
1992
明膠銀鹽相紙
Gelatin silver print
19 × 24.7cm
立陶宛國家美術館藏
Collection of the
Lithuanian National Museum of Art

p. 61

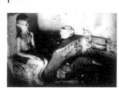

〈世代轉移〉
Generation Shift
1976
明膠銀鹽相紙
Gelatin silver print
20 × 30cm
立陶宛國家美術館藏
Collection of the
Lithuanian National Museum of Art

維吉留斯 · 尚塔 （1952-1992）

尚塔的作品系列類型多元，其共通點是現代、禁慾式的表現手法、精準的構圖和形式上的精確。其關注社會議題，並發展出以社會邊緣族群為主角的不同作品系列。尚塔在其最令人印象深刻的系列之一《學校即是我家》（1980-1983）中呈現特殊教育兒童寄宿學校的日常生活，並強調了理想化的童年之概念與陰鬱的特教機構間之對比。藝術家帶著勇氣和決心，拍攝蘇聯時代官方宣稱不存在的主題，因而遭受當局的批判。

Virgilijus Šonta (1952–1992)

Šonta created photography cycles in various genres, which are characterised by modern, ascetic expression, refined composition, and precision of form. He was interested in social themes and created series that captured socially marginalised groups. One of his most striking series, *School is My Home* (1980–1983), reveals the everyday life in boarding schools for children with special needs, and highlights the contrast between the idealised perception of childhood and the gloomy special-needs institutions. His courage and determination to capture something that did not officially exist in the Soviet era was criticised by the authorities at the time.

p. 62

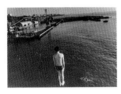

〈飛行，第 4 號〉
Flight, No. 4
1978
明膠銀鹽相紙
Gelatin silver print
16.9 × 24.1cm
立陶宛國家美術館藏
Collection of the
Lithuanian National Museum of Art

p. 64

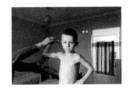

〈炫耀手臂肌肉，第 4 號〉
Showing Off Arm Muscles, No. 4
1980-1983
明膠銀鹽相紙
Gelatin silver print
18.7 × 27.6cm
立陶宛國家美術館藏
Collection of the
Lithuanian National Museum of Art

p. 65

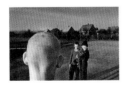

〈後腦杓、兩名男孩與一隻狗〉
Back of the Head, Two Boys and a Dog
1980-1983
明膠銀鹽相紙
Gelatin silver print
16 × 24.7cm
立陶宛國家美術館藏
Collection of the
Lithuanian National Museum of Art

安塔納斯・蘇庫斯（1939–）

蘇庫斯不僅是立陶宛攝影史上最傑出的藝術家之一，也是該國攝影界活躍的成員：1969 年，蘇庫斯於立國首都維爾紐斯（Vilnius）協助建立立陶宛攝影協會（自 1989 年起稱為立陶宛藝術攝影師聯盟），並長期擔任該協會主席。《立陶宛人民》系列匯集了其藝術生涯中所創作的多組系列作品。透過創作，蘇庫斯延續了西方人文攝影學派的傳統，力求捕捉時間和地點的精華，傳達拍攝對象的心理樣貌，並創造出具有情感吸引力的影像。其攝影作品中所捕捉的日常場景展現深刻的人文精神，具有普世性意義。

Antanas Sutkus (b. 1939)

Sutkus has entered the history of Lithuanian photography not only as one of its most prominent artists, but also as a champion of the photographic community: in 1969, he helped to establish the Lithuanian Photography Society (known since 1989 as the Lithuanian Union of Art Photographers) in Vilnius, and was its long-term chairman. He created several photography series that were brought together in the cycle *People of Lithuania*, which spans his entire creative career. In his work, he continues the tradition of the Western school of humanist photography, seeking to capture the essence of a time and place, to convey the psychology of his subjects, and to create an emotionally compelling image. The everyday scenes captured in his photographs become a universal metaphor for human existence.

p. 66

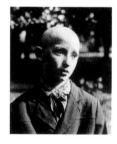

〈盲眼的小紅軍〉
Blind Pioneer
1962
明膠銀鹽相紙
Gelatin silver print
56 × 46.3cm
立陶宛國家美術館藏
Collection of the
Lithuanian National Museum of Art

p. 69

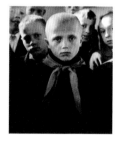

〈小紅軍〉
Pioneer
1964
明膠銀鹽相紙
Gelatin silver print
56.3 × 47.4cm
立陶宛國家美術館藏
Collection of the
Lithuanian National Museum of Art

p. 70

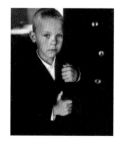

〈兒子〉
Son
1964
明膠銀鹽相紙
Gelatin silver print
59 × 50cm
立陶宛國家美術館藏
Collection of the
Lithuanian National Museum of Art

p. 71

〈飛行員〉
Pilot
1972
明膠銀鹽相紙
Gelatin silver print
56 × 46cm
立陶宛國家美術館藏
Collection of the
Lithuanian National Museum of Art

p. 72

〈大教堂廣場；約會〉
Cathedral Square. The Date.
1960
明膠銀鹽相紙
Gelatin silver print
56.7 × 37cm
立陶宛國家美術館藏
Collection of the
Lithuanian National Museum of Art

p. 75

〈大學路上的馬拉松跑者〉
Marathon at University Street
1959
明膠銀鹽相紙
Gelatin silver print
56.4 × 38cm
立陶宛國家美術館藏
Collection of the
Lithuanian National Museum of Art

瓦克勞瓦斯・史卓卡斯（1923–2017）

史卓卡斯的攝影作品常被定位為抒情寫實主義，富有溫暖、樂觀的氛圍。這些作品強調生活中積極正向的層面，並突顯其美。在著名系列《最後的鐘聲》（1972-1987）中，長期擔任教職的史卓卡斯回到校園拍攝畢業慶祝活動。他敏銳地捕捉到童年至成年間的轉變，呈現掙脫制服束縛的叛逆與情慾，創作出蘇聯時代的青年群像。

Vaclovas Straukas (1923–2017)

Straukas' photography, often described in terms of lyrical realism, is characterised by a warm, optimistic atmosphere. It emphasises the positive aspects of everyday life and highlights its beauty. His most famous series is *The Last Bell* (1972–1987) in which Straukas, who worked for a long time as a teacher, returned to schools to document their graduation celebrations. Not only did he sensitively convey the transformation between childhood and maturity in his photographs, but he also created a general collective portrait of the youth of the Soviet era by exposing hints of rebellion and eroticism unrestrained by uniforms.

p. 76

〈最後的鐘聲〉
The Last Bell
1973
明膠銀鹽相紙
Gelatin silver print
29.8 × 40.3cm
立陶宛國家美術館藏
Collection of the
Lithuanian National Museum of Art

p. 77

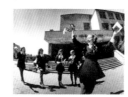

〈最後的鐘聲，第 63 號〉
The Last Bell, No. 63
1978
明膠銀鹽相紙
Gelatin silver print
29.3 × 39.2cm
立陶宛國家美術館藏
Collection of the
Lithuanian National Museum of Art

p. 78

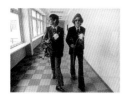

〈最後的鐘聲〉
The Last Bell
1974
明膠銀鹽相紙
Gelatin silver print
29.5 × 40cm
立陶宛國家美術館藏
Collection of the
Lithuanian National Museum of Art

p. 79

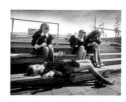

〈最後的鐘聲〉
The Last Bell
1978
明膠銀鹽相紙
Gelatin silver print
29.6 × 39.5cm
立陶宛國家美術館藏
Collection of the
Lithuanian National Museum of Art

p. 80

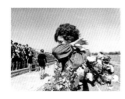

〈最後的鐘聲，第 103 號〉
The Last Bell, No. 103
1978
明膠銀鹽相紙
Gelatin silver print
28.7 × 38.9cm
立陶宛國家美術館藏
Collection of the
Lithuanian National Museum of Art

認同即物件 IDENTITY AS AN OBJECT

吉恩陶塔斯・特里馬卡斯 (1958-)

「重複」是特里馬卡斯創作中的重要元素。他拍攝浴室中用過的物品或衣物並將其分類，以對平凡物件的研究來吸引觀者趨身觀看。特里馬卡斯彷彿在作品中尋找人們平日獨處時展露出的衰敗痕跡，並意圖使平常能輕易辨別的事物顯得陌生，來探究人們的辨識能力。其作品遊走於平淡乏味與模稜兩可之間，鼓勵觀者對「真實的存在」及其時間性進行反思。

Gintautas Trimakas (b. 1958)

Repetition is an important element in Trimakas' work. He uses classification in his images of used items in a bathroom or people's clothes, as a way to arrest the viewer in front of his studies of mundane objects. Trimakas seems to be looking for traces of the decay that unfolds in people's daily lives when they remain alone with themselves as well as traces of their capacity for recognition by defamiliarizing that which usually enables identification. Maneuvering between banality and ambiguity, Trimakas encourages reflection on the themes of authentic existence and its temporality.

p. 88

〈在浴缸中浸濕〉
Wet in a Bathtub
1989
數位輸出
Digital print
41.6 × 41.9cm
立陶宛國家美術館藏
Collection of the
Lithuanian National Museum of Art

p. 88

〈在浴缸中浸濕〉
Wet in a Bathtub
1989
數位輸出
Digital print
41.8 × 41.8cm
立陶宛國家美術館藏
Collection of the
Lithuanian National Museum of Art

p. 89

〈在浴缸中浸濕〉
Wet in a Bathtub
1989
數位輸出
Digital print
41.8 × 41.9cm
立陶宛國家美術館藏
Collection of the
Lithuanian National Museum of Art

p. 89

〈第三個懸掛物〉
The Third Hanging
1989
經調染之明膠銀鹽相片
Toned gelatin silver print
38.2 × 38.2cm
立陶宛國家美術館藏
Collection of the
Lithuanian National Museum of Art

p. 90

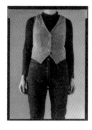

〈軀幹—身體部位〉
Torso - Body Part
1995-1996
明膠銀鹽相紙、層板
Gelatin silver print, laminate
30.7 × 26cm
藝術家提供
Courtesy of the artist

p. 91

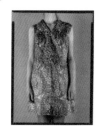

〈軀幹—身體部位〉
Torso - Body Part
1995-1996
明膠銀鹽相紙、層板
Gelatin silver print, laminate
30.7 × 26cm
藝術家提供
Courtesy of the artist

p. 92

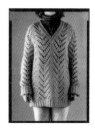

〈軀幹—身體部位〉
Torso - Body Part
1995-1996
明膠銀鹽相紙、層板
Gelatin silver print, laminate
30.7 × 26cm
藝術家提供
Courtesy of the artist

p. 93

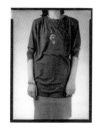

〈軀幹—身體部位〉
Torso - Body Part
1995-1996
明膠銀鹽相紙、層板
Gelatin silver print, laminate
30.7 × 26cm
藝術家提供
Courtesy of the artist

亞封薩斯・布德維蒂斯（1949-2003）

布德維蒂斯和其他同時代年輕攝影師一樣，刻意迴避拍攝特殊事件或物件的慣例，並遠離城市，拍攝郊區生活。布德維蒂斯拍攝的人物通常呈現冷漠和無精打采的樣貌。在其作品〈女子〉與〈男子〉中，他以零碎、片面的形式呈現人物，並未展露他們的臉孔。透過這種方式，藝術家彷彿模糊了女性和男性間的差異，只有幾乎不可見、微不足道的細節才能讓兩者相異之處略顯端倪。

Alfonsas Budvytis (1949-2003)

Budvytis, like other young photographers of his generation, avoided capturing exceptional events or objects, and usually turned away from the city to capture suburban life. The people he photographs are usually apathetic and listless. In his works *A Woman* and *A Man* Budvytis shows people in a fragmentary way, without revealing their faces. In this way, he seems to generalise women and men, their condition is given away only by small, insignificant details barely visible in his photographs.

p. 94

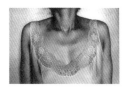

〈女子〉
A Woman
1980
數位輸出
Digital print
24.9 × 36.8cm
立陶宛國家美術館藏
Collection of the
Lithuanian National Museum of Art

p. 95

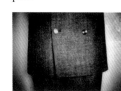

〈男子〉
A Man
1980
數位輸出
Digital print
24.9 × 35.2cm
立陶宛國家美術館藏
Collection of the
Lithuanian National Museum of Art

亞爾吉達斯・赦斯庫斯（1945-）

赦斯庫斯在其藝術生涯初期、1980 年代後半即創作出非視覺、單色調的攝影作品，彷彿在宣稱圖像對於攝影來說並非必要。赦斯庫斯刻意使其攝影作品符合大眾對業餘攝影的印象（構圖不準確、圖像模糊、充滿缺陷、畫面潦草），而其拍攝的主題——城市風貌、室內景象、人物碎片——則皆為默默無名且幾乎微不足道的事物。赦斯庫斯的作品在蘇聯時期受到誤解與批評，卻標誌著立陶宛攝影從沉重、攸關生存層面的主題轉向，更代表著革新的攝影美學。

Algirdas Šeškus (b. 1945)

At the beginning of his career in the second half of the 1980s, Šeškus created explicitly non-visual, monotonous photographs, as though to assert that the image was not necessary for photography. His photographic prints are characterised by an intentional impression of amateur photography (compositional inaccuracy, image blur, defects, scribbles), and the captured motifs – cityscapes, interiors, fragments of figures – are nameless and almost insignificant. Šeškus' work, which was misunderstood and criticised during the Soviet era, marked the withdrawal of Lithuanian photography from weighty, existential themes and a reformed approach to photographic aesthetics.

p. 96

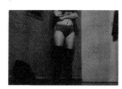

〈無題〉
Untitled
1975-1983
手工上色於明膠銀鹽相紙
Hand-coloured on gelatin silver print
12 × 18cm
立陶宛國家美術館藏
Collection of the
Lithuanian National Museum of Art

p. 97

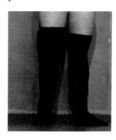

〈無題〉
Untitled
1975-1983
手工上色於明膠銀鹽相紙
Hand-coloured on gelatin silver print
10.8 × 9.5cm
立陶宛國家美術館藏
Collection of the
Lithuanian National Museum of Art

維奧列塔‧布比立蒂（1956- ）

布比立蒂不同於在蘇聯時期出道的同時代攝影師，利用攝影來創建自己的世界／表演。她使用現成的物品——一張紙板、一面鏡子、一塊木板——來重構當時流行的「陰柔女性」刻板印象，同時也試圖正當化自己的存在。布比立蒂的創作特色為透過意想不到的角度和並置，對觀者提出挑戰，從而突顯性別刻板印象的荒謬。

Violeta Bubelytė (b. 1956)

Bubelytė, unlike her contemporaries who made their debut during the Soviet era, uses photography to create her own world / performance. She uses found objects – a cardboard sheet, a mirror, a board – to reimagine the stereotype of the "feminine woman" that was prevalent at the time, whilst also seeking to legitimise her own existence. The character created by Bubelytė challenges the viewer through unexpected angles and juxtapositions, thus reinforcing the absurdity of the gender stereotypes.

p. 98

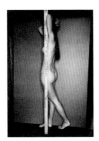

〈裸體，第 8 號〉
Nude, No. 8
1982
明膠銀鹽相紙
Gelatin silver print
22 × 15.5cm
立陶宛國家美術館藏
Collection of the
Lithuanian National Museum of Art

p. 99

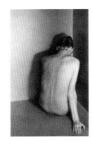

〈裸體，第 23 號〉
Nude, No. 23
1983
明膠銀鹽相紙
Gelatin silver print
22.3 × 14.1cm
立陶宛國家美術館藏
Collection of the
Lithuanian National Museum of Art

p. 100

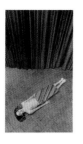

〈裸體，第 25 號〉
Nude, No. 25
1983
明膠銀鹽相紙
Gelatin silver print
22 × 12.7cm
立陶宛國家美術館藏
Collection of the
Lithuanian National Museum of Art

p. 101

〈倒影〉
Reflection
1983
明膠銀鹽相紙
Gelatin silver print
21.5 × 14cm
立陶宛國家美術館藏
Collection of the
Lithuanian National Museum of Art

p. 102

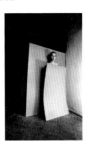

〈布景〉
Composition
1983
明膠銀鹽相紙
Gelatin silver print
23.3 × 14.6cm
立陶宛國家美術館藏
Collection of the
Lithuanian National Museum of Art

金塔拉斯・津克維丘斯（1963-）

端詳津克維丘斯的作品，很難不看出其中所描繪的心力交瘁生活之徒勞。他風格平淡的作品參雜著多愁善感，講述那個時代裡，個人的痛苦情狀，就隱藏在過於華麗的壁紙之下。津克維丘斯並沒有像過去的攝影作品那樣迴避生活；相反地，他準確地揭示了被困在生活中的個人情狀，以自己的方式，讓日常物件彷彿有了生命。

Gintaras Zinkevičius (b. 1963)

It is not hard to see the futility of a worn-out life in Zinkevičius' photographs. His banal works, diluted with sentimentality, speak of the painful condition of individuals at the time, hiding somewhere beneath the overly ornate wallpapers. Zinkevičius does not shy away from life as it used to be, on the contrary, he accurately reveals the condition of the individuals trapped in that life, and so, in his own way, brings the simplest everyday objects to life.

p. 104

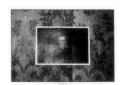

〈一張相片〉
A Photograph
1987
明膠銀鹽照片
Gelatin silver print
24.3 × 35.9cm
立陶宛國家美術館藏
Collection of the
Lithuanian National Museum of Art

p. 105

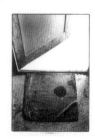

〈一道門檻〉
A Threshold
1987
明膠銀鹽照片
Gelatin silver print
35.8 × 24.4cm
立陶宛國家美術館藏
Collection of the
Lithuanian National Museum of Art

羅馬斯・尤斯克利斯（1946-2016）

尤斯克利斯的城市景觀系列作品聚焦於單一元素的形狀、倒影和光線的效果、以及色彩和攝影技術上的實驗，以創造一個嶄新的攝影現實——一個現實和虛構間的中間點。這種二元對照在尤斯克利斯最著名的系列之一《人類與人形模特兒》（1987-1992）中可明顯看見；該系列分析了人類與物件間的關係、生活的現實及其超現實的模仿。

Romas Juškelis (1946–2016)

In his series of cityscapes, Juškelis focuses on the shapes of individual elements, the effects of reflections and light, and experiments with colors and photographic techniques in order to create a new photographic reality, an intermediate stop between reality and fiction. This dualism is also evident in one of Juškelis' most famous series, *Humans and Mannequins* (1987–1992), which analyses the relationship between humans and objects, the reality of life and its surreal imitation.

p. 106

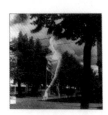

選自《人類和人形模特兒》系列
From the series:
Humans and Mannequins
1988-1992
經調染之明膠銀鹽相紙
Toned gelatin silver print
27.8 × 27.9cm
立陶宛國家美術館藏
Collection of the
Lithuanian National Museum of Art

p. 107

選自《人類和人形模特兒》系列
From the series:
Humans and Mannequins
1988-1992
經調染之明膠銀鹽相紙
Toned gelatin silver print
27.8 × 27.8cm
立陶宛國家美術館藏
Collection of the
Lithuanian National Museum of Art

p. 108

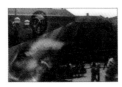

選自《人類和人形模特兒》系列
From the series: Humans and Mannequins
1988-1992
經調染之明膠銀鹽相紙
Toned gelatin silver print
24.9 × 38.2cm
立陶宛國家美術館藏
Collection of the
Lithuanian National Museum of Art

雷米吉尤斯·特雷吉斯（1961-）

特雷吉斯的作品以其能觸動感官為特色。這點一部分是出於手工沖洗照片在美感上所能呈現的細微變化，但這樣的感知性同時也是他拍攝的物件所固有的。看著作品，觀者彷彿可以用指尖滑過床單的皺褶。特雷吉斯聚焦於擁有過去時代和世代痕跡的主題，每張照片都細膩地試圖處理一些跨越時間而留存下來的主題。

Remigijus Treigys (b. 1961)

Remigijus Treigys' photographs stand out for their sensuality. This is partly due to the aesthetic subtleties of his manually developed photographs, but it is also inherent to the objects he captures. It feels as though you could run folds of the bedding between your fingers. And yet Treigys concentrates on subjects that contain the traces of previous times and generations, each photograph carefully trying to touch something that lies beyond time.

p. 110

〈夜夢，第 1 號〉
Night Dream, No. 1
2007
經調染之明膠銀鹽相紙
Toned gelatin silver print
28.8 × 51.5cm
立陶宛國家美術館藏
Collection of the
Lithuanian National Museum of Art

p. 111

〈夜夢，第 2 號〉
Night Dream, No. 2
2007
經調染之明膠銀鹽相紙
Toned gelatin silver print
26.8 × 51.5cm
立陶宛國家美術館藏
Collection of the
Lithuanian National Museum of Art

勞拉・加布施蒂恩（1973-）

加布施蒂恩創作的一大特色是以自己為作品的拍攝對象：藝術家讓自己沉浸於不同情境、場景，並融入其中，以表演誘發觀者省思。其作品風格的另一項要點，是對語言、機運、挑釁式天真、主觀情感體驗和多元文化脈絡進行實驗。加布施蒂恩某次在巴黎走訪博物館，受到〈仕女與獨角獸〉掛毯的啟發，在其系列作品《我該怎麼做才能讓獨角獸把頭靠在我的腿上？》中化身為一名紡織藝術家。那是個真正奇幻的故事：女主角在完成某些條件後，遇到了一隻永遠不會被捕捉的神話生物。由於只有女性才能進行這種儀式，藝術家因此試圖描繪那位有能力看到這種生物的女性。

Laura Garbštienė (b. 1973)

A characteristic feature of Garbštien's creative practice is turning herself into the object of her own works: by immersing herself in various situations, she becomes an integral part of them and provokes the viewer with her performances. Another important aspect of her workstyle is experimentation with language, chance, provocative naiveté, subjective emotional experiences and multicultural contexts. In the series *What Should I Do so That the Unicorn Would Come and Lay Its Head on My Lap?* (2006) Garbštienė, as a textile artist, was inspired by the tapestry series *The Lady and the Unicorn* which she saw at a museum in Paris. It is a truly magical story: after fulfilling certain conditions, the heroine meets a mythical creature, which could never be caught. Since only a woman can perform this ritual, the artist tried to depict that one woman, who has the power to see the creature.

p. 119

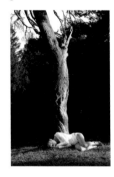

〈我該怎麼做才能讓獨角獸把頭靠在我的腿上？〉
What Should I Do so That the Unicorn Would Come and Lay Its Head on My Lap?
2006
數位輸出
Digital print
80 × 54cm
藝術家提供
Courtesy of the artist

捷斯特・瑪莉亞・欽辛奈迪特（1991-）

欽辛奈迪特同時是一名藝術家和研究人員，自稱為外星人類學家。她透過與神祕怪奇的事物相遇進行影像創作；其作品被理解為既破除了舒適圈——無論是自我、人類、習慣、棲息地、環境——亦對尚未辨認出之存在體提出警覺。《你屬於我》探討從星際探索任務中收集而來的視覺資料，如何建構出一個火星上以人類為本位的現實。美國太空總署（NASA）的研究計畫讓人們能自由存取探測車所拍攝的火星表面照片，使藝術家有難得的機會，得以對尚未造訪的遙遠星球上所製造的數位影像提出質疑。

Geistė Marija Kinčinaitytė (b. 1991)

Kinčinaitytė is an artist and researcher, who calls herself an alien anthropologist. Her image-making practice is defined by encounters with the eerie, understood as both the cessation of the comfort zone — whether self, human, habit, habitat, milieu — and an alertness to a yet-to-be-identified presence. *You Belong to Me* focuses on how the visual data accumulated during interplanetary exploration missions forms an anthropocentric reality of Mars. NASA research projects, which grant free access to photographs of the surface of Mars taken by the camera-equipped rovers, provide a unique opportunity to question the digital images produced on a distant planet which has not yet been directly experienced by humankind.

p. 120

〈無題〉，選自《你屬於我》系列
Untitled
From the series: You Belong to Me
2014
數位輸出
Digital print
56 × 70cm
藝術家提供
Courtesy of the artist

p. 121

〈暗箱〉，選自《你屬於我》系列
Camera Obscura
From the series: You Belong to Me
2014
數位輸出
Digital print
53 × 80cm
藝術家提供
Courtesy of the artist

p. 122

〈無題〉，選自《你屬於我》系列
Untitled
From the series: You Belong to Me
2014
數位輸出
Digital print
80 × 60cm
藝術家提供
Courtesy of the artist

p. 123

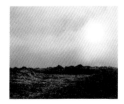

〈無題〉，選自《你屬於我》系列
Untitled
From the series: You Belong to Me
2014
數位輸出
Digital print
73 × 90cm
藝術家提供
Courtesy of the artist

多維立・達吉恩尼（1981-）

《植物記憶：木造猶太教堂》（2019-）是對稀有建築紀念碑和相關文化記憶殘餘的長期研究，旨在重建立陶宛猶太人破碎而不幸的歷史，試圖修補他們失傳的故事。生長在瀕臨滅絕的木製紀念碑上的植物來自歷史悠久的猶太人聚落──其本身已成為紀念碑。象徵和隱喻的語言被轉譯為攝影媒介，不僅表現出悲劇的程度，且透過擴展紀實敘事的力量，重建失落時間和消逝地點的見證。

Dovilė Dagienė (b. 1981)

Plant Memory. Wooden Synagogues (2019–ongoing) is a continuing research into rare architectural monuments and the remnants of cultural memory that surround them in order to reconstruct the broken and tragic story of Lithuanian Jews, to restore their lost narrative. Plants from historic Jewish settlements, the ones found growing on endangered wooden monuments, have become monuments themselves. The language of symbol and metaphor is translated into the medium of photography, showing not only the extent of the tragedy, but also, by extending the capabilities of documentary storytelling, reconstructing testimonies of lost times and places.

p. 124

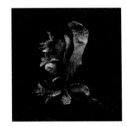

〈軟骨地衣，第 2 號〉，
選自《植物記憶》系列
Ramalina Fraxinea #2
From the series: Plant Memory
2019
藝術微噴
Giclée print
50 × 50cm
立陶宛國家美術館藏
Collection of the
Lithuanian National Museum of Art

p. 125

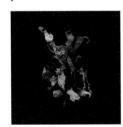

〈軟骨地衣，第 4 號〉，
選自《植物記憶》系列
Ramalina Fraxinea #4
From the series: Plant Memory
2019
藝術微噴
Giclée print
50 × 50cm
立陶宛國家美術館藏
Collection of the
Lithuanian National Museum of Art

p. 126

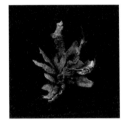

〈軟骨地衣，第 5 號〉，
選自《植物記憶》系列
Ramalina Fraxinea #5
From the series: Plant Memory
2019
藝術微噴
Giclée print
50 × 50cm
立陶宛國家美術館藏
Collection of the
Lithuanian National Museum of Art

p. 128

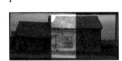

〈卡特奈那木造猶太教堂〉，
選自《植物記憶》系列
Kaltinėnai Wooden Synagogue
From the series: Plant Memory
2019
藝術微噴
Giclée print
6 × 9.5cm
立陶宛國家美術館藏
Collection of the
Lithuanian National Museum of Art

p. 130

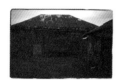

〈亞蘭大木造猶太教堂〉，
選自《植物記憶》系列
Alanta Wooden Synagogue
From the series: Plant Memory
2019
藝術微噴
Giclée print
6 × 9.5cm
立陶宛國家美術館藏
Collection of the
Lithuanian National Museum of Art

p. 131

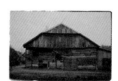

〈羅札里瑪斯木造猶太教堂〉，
選自《植物記憶》系列
Rozalimas Wooden Synagogue
From the series: Plant Memory
2019
藝術微噴
Giclée print
6 × 9.5cm
立陶宛國家美術館藏
Collection of the
Lithuanian National Museum of Art

塔達斯・卡扎克維丘斯（1984-）

《即將消逝》（2014-）反思著「失」而復得的概念，試圖窺探不斷變化的社會。就在過去的幾十年間，連續不斷的移民導致立陶宛的人口減少了將近六分之一。城鎮壟斷了整個經濟、把年輕人吸進城市，而遷移到其他歐盟國家的自由把他們帶得更遠，這一切正無情地改變著該國的鄉村風貌。不免地出現這麼個探問：被農莊和村落點綴的森林和山谷——在這些地方，對時間和親密關係的截然不同理解依然存在嗎？那些不速之客像近親一樣相遇、每位路過之人都會親暱地打招呼的地方，還有多久就會消失殆盡呢？

Tadas Kazakevičius (b. 1984)

Soon to Be Gone (2014–ongoing) reflects the restoration of "lost" and tries to catch glimpses of a shifting society. Just within the last few decades, continuous migration has caused the population of Lithuania to shrink by almost one sixth. Towns have monopolised the whole economy and are sucking out young people into the cities, and as free migration to the other EU countries draws them even further away, all this is inexorably changing our countryside. Just one question inevitably arises: for how long will our forests and valleys be adorned by views of homesteads and villages – places where a totally different understanding of time and closeness still exists? For how long will there still be places where an unexpected visitor is met like a close relative and every passer-by is greeted with a heartfelt "hello"?

p. 132

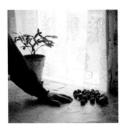

選自《即將消逝》系列
From the series: Soon to be Gone
2014
數位輸出
Digital print
60 × 60cm
藝術家提供
Courtesy of the artist

p. 133

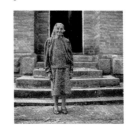

選自《即將消逝》系列
From the series: Soon to be Gone
2014
數位輸出
Digital print
60 × 60cm
藝術家提供
Courtesy of the artist

亞克維立・安格立凱德（1982- ）

《「她」或「是」》（2010）關注攝影家的生活碎片，包含那些從未發生過、確切存在過、繼續延續的片段；換言之，她曾有過或永遠不會有的經歷。該系列探討了女性在分娩（或不育）之前的存有狀態，並將母性的概念與常見的聯想斬斷。這系列關於不連續敘述的作品，融合著渴望、思念、失去或和解的光輝。

Akvilė Anglickaitė (b. 1982)

She or Is (2010) focuses on fragments of her life, those that never occurred, that existed, that continue; experiences which she has had or never will have. The series explores a woman's existence before she gives birth (or not) and unlinks the concept of motherhood from its usual associations. It is about discontinuous narratives that merge into the light of longing, yearning, loss or reconciliation.

p. 134

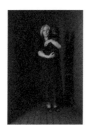

選自《「她」或「是」》系列
From the series: She or Is
2010
數位輸出
Digital print
70 × 40cm
藝術家提供
Courtesy of the artist

p. 135

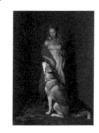

選自《「她」或「是」》系列
From the series: She or Is
2010
數位輸出
Digital print
90 × 60cm
藝術家提供
Courtesy of the artist

p. 136

選自《「她」或「是」》系列
From the series: She or Is
2010
數位輸出、鋁裱
Digital print, dibond
40 × 40cm
藝術家提供
Courtesy of the artist

p. 137

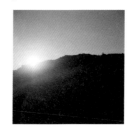

選自《「她」或「是」》系列
From the series: She or Is
2010
數位輸出、鋁裱
Digital print, dibond
30 × 30cm
藝術家提供
Courtesy of the artist

p. 138

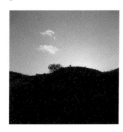

選自《「她」或「是」》系列
From the series: She or Is
2010
數位輸出、鋁裱
Digital print, dibond
60 × 60cm
藝術家提供
Courtesy of the artist

p. 140

選自《「她」或「是」》系列
From the series: She or Is
2010
數位輸出、鋁裱
Digital print, dibond
40 × 40cm
藝術家提供
Courtesy of the artist

p. 141

選自《「她」或「是」》系列
From the series: She or Is
2010
數位輸出、鋁裱
Digital print, dibond
30 × 30cm
藝術家提供
Courtesy of the artist

p. 142

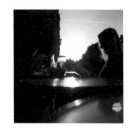

選自《「她」或「是」》系列
From the series: She or Is
2010
數位輸出、鋁裱
Digital print, dibond
40 × 40cm
藝術家提供
Courtesy of the artist

p. 144

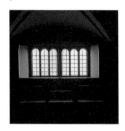

選自《「她」或「是」》系列
From the series: She or Is
2010
數位輸出、鋁裱
Digital print, dibond
60 × 60cm
藝術家提供
Courtesy of the artist

p. 145

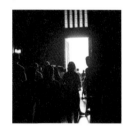

選自《「她」或「是」》系列
From the series: She or Is
2010
數位輸出、鋁裱
Digital print, dibond
30 × 30cm
藝術家提供
Courtesy of the artist

揭幕

尋探立陶宛攝影中的認同

UNCOVERINGS

The Search for Identity
in Lithuanian Photography

指導單位	中華民國文化部
主辦單位	立陶宛國家美術館、國立臺灣美術館、國家攝影文化中心
協辦單位	中華民國外交部
合作夥伴	立陶宛文化協會

發行人	梁永斐
編輯委員	汪佳政、亢寶琴、黃舒屏、蔡昭儀、林明賢、尤文君、賴岳貞、曾淑錢、張智傑、陳俊廷、駱正偉
策展人	烏格涅・瑪麗亞・馬考史凱德
協同策展人	尤斯蒂娜・奧古斯地德
主編	黃舒屏、蔡昭儀
執行編輯	鄭舒媛、林問亭
展覽執行	克莉絲蒂 ・ 阿根泰德 臺中—杜依玲、臺北—林問亭
主視覺設計	理式意象設計
美術編輯	范綱燊
翻譯	章舒涵、許淳涵
校對	賴駿杰、杜依玲、林問亭、鄭舒媛、陳力榆、林學敏
特別感謝	托瑪斯・伊萬納斯卡斯（立陶宛文化部 駐外文化參事） 歐淑娜（立陶宛在臺社群協會負責人）

展覽日期	臺中— 2022 年 4 月 9 日至 2022 年 7 月 3 日 臺北— 2022 年 9 月 8 日至 2022 年 11 月 13 日

出版單位	國立臺灣美術館、國家攝影文化中心
地址	403414 臺中市西區五權西路一段 2 號
電話	04-23723552
傳真	04-23721195
網址	https://www.ntmofa.gov.tw https://ncpi.ntmofa.gov.tw

製版印刷	禾順彩色印刷製版股份有限公司
出版日期	2022 年 4 月
ISBN	978-986-532-571-8
GPN	1011100388
定價	新臺幣 700 元
印製數量	1000

封面用圖

安塔納斯・蘇庫斯
〈大學路上的馬拉松跑者〉 | 1959

Cover Photo

Antanas Sutkus

Marathon at University Street | 1959

Supervisor	Ministry of Culture, Republic of China (Taiwan)
Organizers	Lithuanian National Museum of Art, National Taiwan Museum of Fine Arts, National Center of Photography and Images
Co-organizer	Ministry of Foreign Affairs, Republic of China (Taiwan)
Project Partner	Lithuanian Culture Institute
Publisher	LIANG Yung-Fei
Editorial Committee	WANG Chia-Cheng, KANG Pao-Ching, Iris HUANG Shu-Ping, TSAI Chao-Yi, LIN Ming-Hsian, YU Wen-Chun, LAI Yueh-Chen, CHANG Chih-Chieh, CHEN Chun-Ting, LUO Zheng Wei
Curator	Ugnė Marija MAKAUSKAITĖ
Co-curator	Justina AUGUSTYTĖ
Chief Editors	Iris HUANG Shu-Ping, TSAI Chao-Yi
Executive Editors	CHENG Su-Yuan, LIN Wen-Ting
Coordinators	Kristina AGINTAITĖ Taichung — Ileana TU, Taipei — LIN Wen-Ting
Key Vision Design	Idealform
Graphic Design	Eason FAN
Translators	CHANG Sur-Han, Michelle HSU Chun-Han
Proofreaders	Jay LAI Chun-Chieh, Ileana TU, LIN Wen-Ting, CHENG Su-Yuan, CHEN Li-Yu, LIN Hsieh-Min
Special Thanks	Tomas Ivanauskas (Culture Attaché for China and S. Korea, Ministry of Culture of the Republic of Lithuania) Aušra Andriuškaitė (Chairwoman of Lithuanian Community in Taiwan)
Exhibition Dates	Taichung — April 9, 2022 - July 3, 2022 Taipei — September 8, 2022 - November 13, 2022
Publisher	National Taiwan Museum of Fine Arts, National Center of Photography and Images
Address	No.2, Section 1, Wu Chuan West Road, Taichung 403414 Taiwan
TEL	+886-4-23723552
FAX	+886-4-23721195
Websites	https://www.ntmofa.gov.tw https://ncpi.ntmofa.gov.tw
Printer	Her-shuen Enterprise Co., Ltd
Publishing Date	April, 2022
ISBN	978-986-532-571-8
GPN	1011100388
Price	NTD 700
Amount of Prints	1000 Copies

國家圖書館出版品預行編目（CIP）資料

揭幕：尋探立陶宛攝影中的認同 = Uncoverings : the search for identity in Lithuanian photography /
黃舒屏 , 蔡昭儀主編 . -- 臺中市：國立臺灣美術館 , 國家攝影文化中心 , 2022. 04

 184 面；18.5 × 24 公分

ISBN 978-986-532-571-8(平裝)

1.CST: 攝影集

 958.4781 111004287